# MY PLUNDER
## Westerners and Warriors

True Events and Great Art to
Entertain, Inspire, and Tell of the
Cowboy Way.

Myles Culbertson

Illustrated by Mike Capron

Copyright © 2019 by Myles C. Culbertson
All rights reserved

ASIN 1097110117

"When a day passes, it is no longer there. What remains of it? Nothing more than a story. If stories weren't told or books weren't written, man would live like the beasts, only for the day. The whole world, all human life, is one long story."   Isaac Bashevis Singer

| | |
|---|---|
| Foreword | 7 |
| About the Artist | 9 |
| Chapter 1: A Visit to Chaperito | 11 |
| Chapter 2: Bud Clayton | 31 |
| Chapter 3: Little Red | 47 |
| Chapter 4: Colonel Bob Scott | 75 |
| Chapter 5: Georgia's Wagon | 99 |
| Chapter 6: The Outlaw's Reward | 161 |
| Chapter 7: The Vote | 177 |
| Chapter 8: Apishipa, a Journey | 197 |
| Adios | 213 |

# FOREWORD

Back in the days when the cowboys of history plied their trade on the big outfits they travelled light, usually carrying with them little more than their saddle and canvas-wrapped bed. Rolled in the bed, a cowboy's possessions usually consisted of a change of clothes, an extra pair of boots maybe, and a few personal things like a razor, comb & the like; maybe a pocket watch, writing material, a picture or two, maybe a book, maybe a Bible, a few dollars, keepsakes and letters, not much more than that. His possessions were commonly called his plunder.

The writings in this book are, in some ways, possessions of mine, a collection of memories and stories that belong to me and a few people I have known; keepsakes and mementos of days gone by. They are, in a sense, my plunder.

One story was not authored by me, but rather by Matthew Peterson. When you read it, you will understand why it is included in this collection.

*Myles Culbertson*

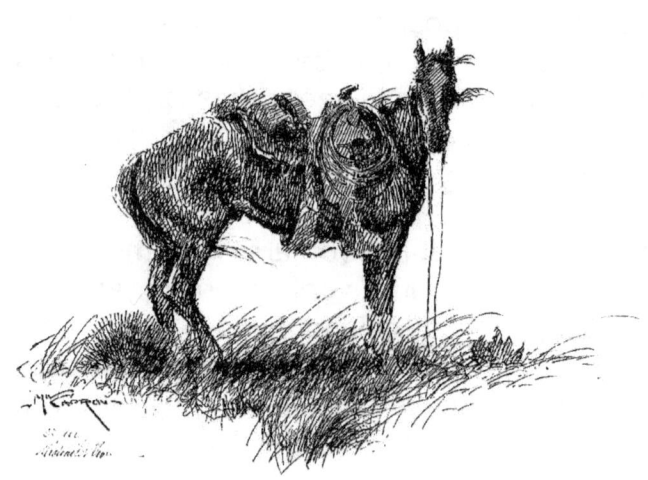

## ABOUT THE ARTIST

Michael Capron was born January 19, 1945. Upon graduation from high school, he worked on ranches in southern New Mexico and West Texas until 1965 when he joined the United States Marine Corps. A combat veteran of Vietnam, Sergeant Capron was honorably discharged in 1968 and returned to Texas, where he and Anne married in 1969. They combined ranching and art until 2013 when they made the decision to move to Sheffield to take on his art career full time.

Seeing life as painting and painting as life, Mike lives his art and shares it in books, magazines, art shows, museums, galleries, and private collections. In his words: "I have always been fascinated by three things: ridin', ropin', and paintin', and know the challenges in all three of these art forms. "Nobody rides every horse, catches every cow, or makes a masterpiece every time. I love the problems of creating a picture that tells a story someone can relate to and feel connected. It is a means of communication since the first cave wall artist. The stories are endless, all worthy of a painting or drawing."

# CHAPTER 1

## A VISIT TO CHAPERITO

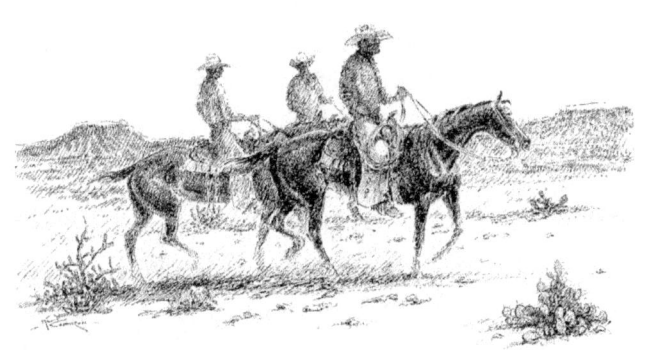

The Gallinas River is, by any account, a minor waterway. Heading in the Sangre de Cristo Mountains in Northern New Mexico, it escapes the mountains through the rugged Gallinas Canyon making its way through the equally minor city of Las Vegas before meandering down a rocky escarpment to the lower country of mesas and cedar breaks, eventually indenturing itself to the long and better known Pecos River. Along its course lie the dead remnants of small communities whose stories are pretty much lost to time. Just the names remain and only then in scant recollections: San Augustin, Lourdes, La Liendre, Los Torres, Aguila, Salitre, others. The last of these was abandoned to history in the late 1950s when the surrounding Chapman Ranch bought out the remaining

residents of the tiny Chaperito Land Grant. Chaperito had been, from its beginnings in the 1840's, a rustic collection of farms and grazing lands anchored by a church, one store/post office, and a cluster of rock and adobe homes peering from a rocky bluff over the Gallinas. The residents were Hispanic farmers, descendants of Spaniards who had settled the northern reaches of Spain's American empire in the 1600's. Situated on the ramparts of "civilization" as it was considered by the elites of Northern New Mexico, this area's citizens of Spain, and later Mexico, were unlike the "polite society" of Santa Fe and Taos. They were often the disenfranchised and marginalized orphans and outcast of a harsh colonial domain. In the early days of Chaperito's life, many of its residents were Comancheros – traders who enjoyed a unique relationship with the often entrepreneurial and always dangerous Comanches of the Llano Estacado, aboriginal proprietors of a vast world beyond the eastern horizon.

Violations of the peace of agriculture's seasonal life cycle were few and seldom in this isolated village, but when one did occur, the tale was worth telling. Once, in the mid-1800's, soldiers from the nearby fort known as Hatch's Ranch viciously drew blood at a Chaperito fandango in revenge for the murder of one of their comrades. On another occasion, in a more official action, those soldiers attacked a large band of Comanches

that were trading with, or maybe hiding out with, the local villagers.

In later years, after the Comanches had relinquished the plains, much of the region was taken up by new entrepreneurs – gringos who drove large herds of cattle north and launched vast ranching operations. The Gallinas and its tributaries and nearby springs became vital sources of water, defining the size and shape of new emerging cattle outfits. In those days the community occasionally entertained a cowboy or two off the surrounding ranches. Such events were typically peaceful, but not always, like the time in 1884, when sheriff's posse deputy Johnny Hurley, a former member of the Seven Rivers Gang, desperados who had gained notoriety in the Lincoln County War, was gunned down in Chaperito by fugitive horse thief Nicolas Aragon, a resident of the village.

As the decades passed, the citizens of Chaperito contentedly managed their crops and livestock, raised their children, and buried their dead in a natural cycle of agrarian life, resigned to and satisfied with their cyclic, isolated subsistence.

By the second half of the 20th century Chaperito was slipping quietly toward extinction in a world that was passing it by without notice. The area ranches occasionally bought some hay or hired their men, but for the most part Chaperito was left to its own

isolation and peace.  That is, with the exception of one summer day in 1953.

Three men working for the Park Springs outfit were riding that ranch's upper mesa country. They were pals; all three expert at their trade, diverse in their respective ascents as top hands.  Nick LeCompte was a carefree young Texan with disheveled good looks, wild and unpredictable as a brushfire.  He was well known for his hardfisted fighting nature toward men, womens' spellbound attraction to him, and his soft, almost magical, touch with young horses.  Nick was a loyal friend and reliable comrade in arms, seldom caught without his trademark smile, readiness for a scrap, or a plan for the next adventure.

Harold Martz, slightly the elder of the three, looked a bit more like the hero of a "B-western" movie.  His roots in the sagebrush cattle empires of western Colorado and Wyoming were evident in the subtly fancy equipment he wore and rode.  In contrast to the pinch-brimmed hats, shotgun leggings, and short-shanked roping spurs of the New Mexico brush-poppers, Harold wore a wide-brimmed hat and silver mounted spurs that sang in a clear ring as he rode or walked. The slit pocket of his big bat-winged chaps usually displayed the butt of a .44 caliber Colt.

Joe Gomez, born Jose Maria Gomez, was the youngest of the trio.  He had walked away at age 10 a little over a decade earlier from his

home a few miles upstream from Chaperito to find a place of belonging with the great Bar Y Ranch near Santa Rosa. That's where he learned to speak English, acquiring the distinct west-Texas accent of the cowboys, and where he became known simply as 'Joe'. By the time he was a teenager Joe had already become a dead-eyed roper and salty bronc peeler – a real hand in the esteem of the men around him. Now he was a newlywed with a new job at the Park Springs.

These three cowboys, skilled professionals working for the same outfit, had come together on the Park Springs from vastly different backgrounds; but here they were pals sharing a freedom and wildness that defined the unshackled life of a cowboy in those days.

The Park Springs Ranch, part of whose eastern edge joined the Grant, sprawls out on a hundred square miles under the south face of a thousand foot high escarpment that runs across much of northeastern New Mexico. The northern third of the Park Springs, below that caprock, is a broken, juniper and pinon covered, mesa carved by small creeks draining through rugged sandstone-sided canyons and draws. The canyons gape south and east, opening to grama-grass plains dotted with junipers scattered sparsely over low hills.

Joe, Nick, and Harold were prowling parts of the Park Springs mesa country, a typical daily job on the outfit. They would scatter out over the expanse of a pasture to get a good look at the cattle and inspect the condition of the grass, water and fences. The horses they rode were accustomed to this daily "long-trot" routine and were plenty tough enough to carry out their charge. These cowponies were able and reliable partners, but not necessarily averse to an occasional test of their human companions' credentials in a stormy tantrum, just making sure the man was as good as the horse.

The three men had joined back up after riding out the corners and crannies of the "East Mesa" pasture. As they pulled up their ponies on a rocky point, they could see, in the far distance, where the Gallinas River flowed onto the ranch below Chaperito. Upstream from there they could make out the glint of tin rooftops in the village, some three or four miles away. The sun was high overhead by now, and the three cowboys had planted a lot of horse tracks already. Things looked pretty good in the East Mesa and the work had wrapped up a little earlier in the day than they had planned. Harold pulled a sack of Bull Durham from his vest pocket and rolled a smoke as the three gazed at the expanse below them. A thirst had built up, and that became the important tactical discussion.

There is an uncanny ability among some folks, particularly of the ilk here gathered, to possess vital intelligence, such as where there might be a cold, or at least shade-cool, beer. There was a fellow in Chaperito that made his own home brew and probably would have some on hand. It was not unreasonably out of the way from their course home, and, after all, a little good will between the Park Springs and the Village should be worthy of some neighborly time spent in brotherhood and fellowship. The Boss would surely endorse such a gesture of diplomacy, so, having convinced themselves of the importance of the mission, they turned their cowponies down a rocky descent off the mesa in the direction of Chaperito. Moving through the oak-brush that covered a faint deer trail, the men allowed the horses their heads as they took each cautious downward step. Shards of sandstone slid from under their hooves and rolled away down the steep slope.

Nick chuckled at his little hackamore bronc who, bewildered by the descent, seemed to gain some security by keeping his head next to the croup of Harold's lead horse as they picked their way toward level ground at the canyon's mouth. Joe followed on his mount, Trigger, who never seemed bewildered at anything. His attitude was always the same – insulted to have a rider aboard.

Trigger was not one of the ranch company's raising. The big bald-faced bay had been

traded to the ranch by a neighbor, Jay Cox. The men on the Park Springs often good-naturedly called the horse "Jay Cox" because they were said to recognize a similar undefeated temperament in both Jay Cox, the man, and Jay Cox the horse; more simply stated, "they were both about as ornery".

Anyway, old Trigger (or Jay Cox, if you choose) could buck and was usually willing to when the situation offered an opportunity, like a quail rising from the grass ahead of him, or a juniper branch brushing by him in the wrong way, or a rope around his leg, or some other offense to his sensibilities. He would usually buck straight, jumping hard and kicking high. Sometimes he would shut his eyes in his temper fit, "bucking blind", as they say. If you were a pretty good hand, he wasn't all that un-rideable, except he would simply not quit, wearing his rider down sometimes into defeat. Joe liked the horse, mostly because of his propensity to pitch.

Joe Gomez, whose diminutive frame stood little more than 5 1/2 feet, was an unconventional bronc rider. He rode a flat seated saddle with heavy roping stirrups. A small leather belt was laced through the fork of the saddle's front end, and when a horse broke in two with him he would get his hand into that "bucking strap", kick his feet out of the broad stirrups, and spur the horse in the shoulders at every jump, much like a rodeo bareback rider. His radical style created a

wild spectacle of flying legs and flailing stirrups, and then, when the half-percheron "Jay Cox" was the dancing partner, it became an almost cartoonish contest between small and huge in a swirling storm.

The three riders reached level ground, watered out their horses at a windmill near the foot of the east mesa, and struck out in a long trot passing juniper groves and negotiating through cholla cactus flats, seeking the prospect of cool repast on the shade-blessed banks of the Gallinas.

They approached the village from the west, their shadows slightly leading as they passed a few scattered outlying rock farmhouses among the green patchwork of alfalfa and corn fields where a few men and boys with shovels walked about, managing irrigation water. The small dark windows of the homes offered occasional red splashes of color from geraniums nested in gallon coffee cans. Some doorways would partially reveal the shy suspicious stares of women in black dresses and scarves, and black button-up shoes. Ahead of the riders, low-set buildings rested on the high bluff across the creek, resignedly staring down the heat and dust of a mid-summer day. The horses splashed across the Gallinas, whose rushing ruddy water betrayed the past several days' rain-showers in the high country. The shod feet of the horses made drenched clopping sounds on a submerged rock shelf, and the cool water

scattered on the backs of the two lead riders. In high spirits, the men kicked their horses into a lope out of the creek toward the hill and a non-descript adobe house with a grizzled cottonwood standing guard, shading the bare swept floor of a front yard. Reaching their destination, they slid their ponies to a stop and stepped off to the welcome of the local brewer, always ready for good conversation and a tester for his latest masterpiece.

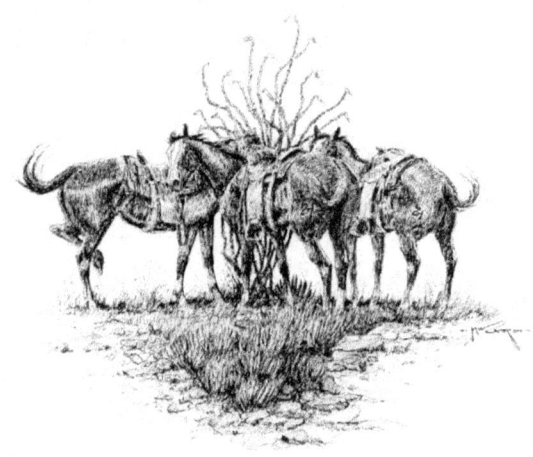

The beer wasn't cold, and its bitter character wouldn't satisfy many palates, but on that day in that company it was close enough to nectar from heaven. The three cowboys and their benefactor pushed their hats back and reclined under the cottonwood's protective shade, allowing the golden beverage to make their jokes funnier and their conversation more important. Looking toward the other end of the thoroughfare, more a narrow rock-strewn field than a street, with houses on each

side, they could see the village's little store and post office directly facing them some 100 yards away.

Some of the homes along the street were close enough together to share common porches made of corrugated tin tops projecting 7 or 8 feet from the eaves, and held up by gnarled cedar posts. They were floored with pine 1X4s nailed together a little above ground level. It was a pleasant afternoon, and a couple of old men were seeking refuge from the sun on one such porch, sitting on small ladder-back chairs, quietly visiting about things only old men know to be important.

The afternoon had been made pleasant by the generous sharing of home brew, but the shadows were lengthening, and it was getting time to head to the ranch. Our three cowboys bid their host adios as they untied the bridle-reins and cheeked up their ponies, catching the near stirrup and swinging into the saddle. Joe was short, and Trigger was tall and powerful, so he took a tight short-rein together with a fistful of mane, hopped as high as he could to catch his stirrup, and rolled up Trigger's side into the saddle.

Starting away from the house, they heard a shout: "Hey Joe!" They looked around and recognized a local that did occasional day-work for the Park Springs. "Does your horse ride double?" "Sure!" says Joe with a big grin. "Where you headed?" "To the post office."

"Sure – 'subete,' ..get up!"  With that, Joe reached down and locked arms with his passenger, swinging him up behind the cantle of the saddle.

Now old Jay Cox took a different view of this kind of charity. He didn't even like one man up, so two was intolerable by every measure. Joe had a lot of nerve and this horse was going to change things for these men.

Joe fed some slack into the reins and touched his spurs to Trigger, expecting his mount to step out in a trot down toward the little store/post office and, for a few steps, he did. Then, suddenly, Trigger's head disappeared from sight and Joe was looking at nothing in front of him but rocky ground inviting him to swan dive onto it. At the same time, Joe felt the slam of the horse's high explosive jump. Coming down and hitting the ground on his front feet, Jay Cox leaped again and then fell into a jolting, twisting rhythm as he bucked high and hard down the street toward the store, bawling and coughing with each jump. Joe, from the first jump, kept grabbing for his bucking strap and missing while trying to fight off two wildly grappling arms around his face and his throat, and two heavy flying stirrups punishing him on both sides. At the top of every jump the extra 160 pounds of panic behind him pulled hard upward, and then drove his upper body forward over the saddle horn with each crashing blow to the ground. All Joe could see was a swirling confusion of

ground, horizon, and buildings framed between groping clawing fingers, while his throat was closing under the grip of an inextricable arm. He was too busy trying to stay aboard Jay Cox to be able to fight off his wrestling companion, so there they went, a crazy mix of 1 horse and 2 humans, descending upon the modest little store and post office at the end of the street.

Trigger bucked straight to the front of the store, hitting the ground and suddenly turning away so hard that Joe and his baggage were launched with perfect aim through the doorway. They crashed, rolling onto the floor in front of the terrified proprietor. As quickly as they stopped rolling, Joe looked up at the post mistress, frozen behind the counter, and said through his broad smile, "we got any mail?"

Meanwhile, Trigger continued his tantrum, bucking blindly on an oblique trajectory away from the store, hitting the side of a rock outbuilding and turning in wild jumps onto the porch of the two joining houses. The two old men dove from their chairs out onto the street. Every time Trigger jumped he lifted the porch roof off the cedar columns, allowing the corrugated tin to fall to the ground, and every time he came down he crashed through the pine porch floor. He tore through the entire length of the 2-house porch, the posts pushing out, the tin falling down, and the floor flying into splinters.

Exploding out from the destroyed porch, Jay Cox broke into a run down the wide street. Nick grabbed the coils of his rope and quickly shook out a loop, spurring his bronc into a hard run, angling toward the big bay. He swung the loop twice and let go. The lariat came to life like an airborne snake, settling deep around Trigger's neck. As he pulled on his bewildered little bronc trying to stop the bay freight-train, Nick's saddle found itself pulled forward of the withers and partway up the horse's neck. When the dust cleared, the little horse was standing spraddle-legged and wide eyed, snorting, ears drawn forward, with an intense surprised look up the rope at the huge equine he had just stopped.

People were peering from windows and beginning to tentatively walk out into the street to get a sense of what had just happened.  As the crowd gathered, Joe charged from the post office door while Nick was leading Trigger in a lope toward him. Harold followed, spanking Trigger with his quirt to keep him from balking.  Joe hurriedly mounted the big bay, and the three spun their horses away from the store and, letting out a war whoop, left in a run.  Harold, hard on the heels of the other two, was inspired to add to the moment, pulling the .44 out of his chaps pocket and firing into the sky until the cylinder was empty.

The sun sank low, casting long shadows across the wreckage, as one of the old men stood in the middle of the road with the back of a broken chair in his hand.  He gazed resignedly and a little bit amused at the escaping cowboys as they hit the rushing Gallinas, looking like Billy the Kid's Regulators running from the law.  Maybe the old man was seeing more than just the sun setting on the excitement of that day.  Chaperito had held stubbornly to its existence for 150 years, but the world was moving on, leaving behind this little culture of quiet rural life.

The three compadres were finally headed home, laughing and reliving the afternoon's adventure, but at the same time wondering if the Boss might have to pay for a town.  Oh well, they could get along without the next few

paychecks. Nick and Harold could pick up the tab for the young newlywed. As it would turn out they didn't need to worry about that. The people of Chaperito had always built and rebuilt on their own, and, besides, the afternoon's event had provided worthy entertainment.

Cowboys are not a dying breed. That is a myth as old as the profession itself. As long as there are ranches to run and cattle to raise, there will be cowboys. Their ways change to meet the reality of the times. In these cowboys' youth, time was measured in the moment and the moment was, they assumed, forever. That is what all cowboys have done. But time doesn't submit to mortal expectations. Change, inevitable and unrelenting, would overtake their wild, free refuge and ultimately bring their kind into a different world with different rules, like it always had. Two of the three would, in a few years, meet disillusionment and tragedy before their time, casualties of the changing world. The third would find his place of belonging in that world as one of the most respected ranch managers of the region. For a brief time the three young wild cowboys were pals, immortal and indestructible, but the ever pursuing thief of time would finally assign them, like the village itself, to history, and only then in a few scant recollections.

The Gallinas, whose mirroring waters fed Chaperito and washed past the fleeting steps

of the three cowboys, has hidden much of its history and protected its secrets in an irreversible pilgrimage to the sea, taking into the deep water most of the traces of conquistadors, colonists, Comanche warriors and their allies, soldiers, drovers, outlaws, cowboys, and all others who touched it. But, once in a while, we can dip our cup in the flow and retrieve from it a good story or two to be told before they disappear in the swirl.

***

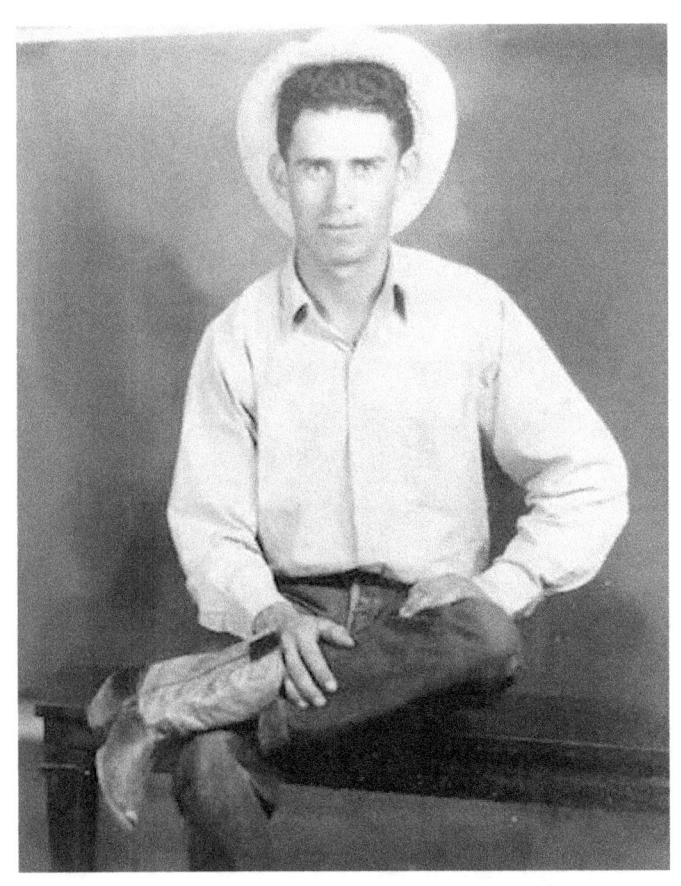

*Young Joe Gomez*

# CHAPTER 2

## BUD CLAYTON

Tough ... that is always the first term that comes to mind whenever I think of Bud Clayton. Even in his later days the man's stature and demeanor testified of a life lived in a world intolerant of fear or weakness. Bud's countenance revealed a seasoning gained in the transition from territorial frontier to modern industrial society. His inscrutable expression was at once fierce and pleasant,

impermeable as a canyon's rock face. His piercing stare could end a fight before it started.

He was my great uncle, whose wife Bess was Bill Culbertson's sister. Strikingly beautiful, she was Bud's softening complement. I knew the two of them when I was a child. In those days Bud was a police chief and later a judge in Tucumcari, New Mexico, but he had been a cowboy much of his life, working for some of the major cattle ranches around the turn of the century. A notorious bronc rider, it is said he offered a standing bet that he could put silver dollars in both stirrups under his boots, ride any bucking horse till it quit, and the dollars would still be there. Bud rode in some of the biggest rodeos of the day, like Cheyenne and Pendleton, but he was always more at home on the big outfits, not in the rodeo arenas.

In the days entering the 20th century, New Mexico was, like much of the West, riding the wave of a changing agricultural economy. Demand for more and better beef to nourish the nation's explosive industrial growth caused capital to roll into the West, establishing vast ranching empires with large herds of improved quality "one iron" cattle. The area below the northeastern New Mexico caprock was choice cow country, sought after by cattlemen and entrepreneurs. Some of the outfits, like the Bell Ranch, were here to stay, creating their own chapters in the history of

the state and the business. Others were temporary, filling immediate demand and moving on to other enterprise or oblivion. All were big, and all needed crews of expert men to care for their investments and get the cattle to market.

Part of that cow country is where the Pecos and Gallinas rivers join. Born in the same range of mountains, the two waterways are cousins of sorts, finding their own separate ways out of the Sangre de Cristos, pursuing tortuous pathways to the low country. The two find each other below the great escarpment in a hilly plain of abundant grass and scattered prickly pear, chollas, and junipers. Occasional palmillas, slender-spined cousin of the yucca, stand guard over the slopes and river breaks where the rivers join forces.

Before the speculators and land traders opened the way for cattlemen and their financiers, Spanish settlers had made an uneasy life here in the confluence of Apache and Comanche domains. They called the area "La Junta". It was destined to become a world of cowboys, tough and adventurous, making their mark over the next century in this region of mesas, creeks, springs, grass and cattle. For a while it was Bud Clayton's world.

A few miles north and west of the Junta, the thousand foot high Apache Mesa rises, the western anchor of the caprock escarpment

reaching across northeastern New Mexico. Near the mouth of a canyon that cuts through the convergence of that high escarpment and a lesser mesa to its south, a little rock ranch house and barn called Chupainas Camp had been built back in the 1870s. Bud Clayton spent the summer of 1912 there alone, breaking horses for the HOW outfit, a cattle company running on the surrounding ranchland.

The way he described it, there was a large round corral where he would rope an untouched bronc, wrestle a saddle onto him, and step aboard. The corral gate was rigged so that when the latch was pulled it would slowly swing out, opening under its own

weight. The horse would throw his fit, and when bucking turned to running, and Bud thought he had him kind of handled, he would pull the gate latch as they ran past, making one more circle inside the pen. The gate would creak open and out the hole they would go, breaking into the wide open. By the time horse and rider made it back home, the pony was on his way to becoming an esteemed tool for a cowboy. Bud broke 20 horses that one summer at Chupainas.

Some time previous, the Red River Cattle Company, owner of the famed Bell Ranch, held the lease on a large parcel of the same country. Bud was a Bell cowboy in those days, and the outfit sent him with a number of other Bell hands there to look after the cattle and fend off any rustlers. The cowboys called it the Philippines, because the ranch was so far west from the Bell headquarters. The Gorras Blancas (White Caps), a violent frontier vigilante group, were raising hell in the area, running off cattle and cutting fences in the name of disputed property claims and hatred for these new stewards of the land. Bud spoke only a couple of times of an incident when a Bell cowboy came upon a whitecap cutting the Bell drift fence, and of an ensuing battle that ended with smoke rising from the barrel of a six-gun and a whitecap dead on the ground. He never admitted who the cowboy was.
For a time during that first decade of the century, Bud Clayton was breaking horses

upstream from the Junta for the Conchas Ranch, a sizeable operation that lay under the caprock, eastward from the Gallinas River. It was a broken grama grass and cactus country, spotted with areas of dense juniper and pinon covered canyons. One of the Conchas neighbors was Chaperito, a small community land grant anchored on the banks of the Gallinas River, its village perched on a rock bluff at the edge of the passing waters, its farmland and pastures sprawling out around the village.

Bud had a helper, a Spanish youth, helping ride the horses he was starting. Bud would typically start a horse and get a few days on him, and then turn the horse over to the boy and start another. In the doing, he took a liking to the kid and had become something of a mentor, making a pretty good horseman and cowboy out of him. The boy called his taciturn companion "Senor Bud", even though there weren't that many years between them. So it was one summer day as Bud and his young sidekick were prowling the river breaks near the Chaperito grant. He and the boy were riding their broncs along a rocky ridge in sight of the village. Bud hadn't been away from the cow camp for a long time and had a bulge of letters, written over the past few weeks, in his chaps pocket. There was a post office in Chaperito, so Bud handed a dollar to the kid and sent him to the village with the letters. "I'll ride this rough country out. You lope down to the post office and mail

these for me, and then you can ride out the river bottom. We'll meet back up where the Indio draw comes in."

The boy reined his horse off the little rock bluff and headed toward Chaperito, a couple of miles away. Approaching the little rock and adobe village from the southeast, he could see the emerald strips of farmland touching the river beyond the one-story houses and steepled church that surrounded a broad dirt street. The only commercial establishment fronted on the street, a stone and plaster building that housed the store, post office and saloon, all in one room. As he entered the village, a few of the citizens gave notice to the kid who was riding a pretty good saddle on a better than usual horse and whose clothes and hat betrayed some influence of the gringo cowboys of the big ranch. Though native to the culture, he felt like a stranger in this village, known for decades as being close-knit and hostile toward outsiders. Forty years earlier the citizens had been more likely to choose friendship with the dangerous Comanche than with the gringo ranchers in the area or the soldiers of the fort at nearby Hatch's Ranch.

He pulled up his horse in front of the post office and dismounted, tentatively stepping onto the porch and entering the store. Across the room from the entry was a cage-fronted counter that served as the post office. On the boy's left was a counter behind which shelves

were stacked with a number of canned foods, bolts of cloth, household items, lamps, and the like. Also there was an open-fronted cabinet with a few bottles of whiskey on display; below that, several bins containing flour, beans, rice, and other foodstuffs. A small square table was near the window on the other side of the room, where three men were quietly slurring some sort of argument. They glared from under their battered hats at this trespasser.

No one was behind the postal teller cage, so the kid asked the room's only occupants who he could see about buying stamps and depositing the bundle of letters. With sudden curiosity one of the men inquired how he was to buy the stamps. The boy pulled the dollar from his pocket and once again solicited their help. The man took interest. A thin smile cutting his face, the man rose from his chair, grabbing the dollar from the boy's hand and sitting back down. The boy gestured after him, protesting the seizure. The man stood back up, gripping the boy's shirt and, with his other fist, knocked him to the floor and started kicking him in the side. As he tried to stand, the man grabbed his belt and shirt, kicked the door open, and pitched the boy out on to the ground at his shying horse's front feet. He could hear laughter inside as he struggled to his feet, untied his startled horse, and slowly swung his leg over in the saddle. Jaw pounding and ears ringing, he turned the pony for the edge of the village. He stood up in his

stirrups with a painful wince and hit a long trot for the river, one silver dollar lighter and full of dread about what Bud was going to say.

The sun was high as the kid prowled the river, hastily looking through the cattle that had come down to water and shaded up to wait out the afternoon. The movement of the horse helped loosen the stunned muscles in his side. He was in a hurry, hating the burden of undelivered bad news. Whatever trouble he was going to be in with Senor Bud, he wanted to get it over-with and done.

He picked his way past a rugged cut where the creek came through to an open grassy flat. Far ahead, he spotted Bud peering upstream from where the little draw known as the Indio Arroyo joined the Gallinas. He was sitting relaxed in the saddle, his crossed forearms resting on the saddlehorn and his hackamore bronc standing half asleep in the warm noon sun. The colt threw his head up and pricked his ears toward the approaching horse and rider, but Bud had already been watching them a good while. As the boy kicked into a lope across the grassy flat, Bud observed how the agile blood-bay moved and changed leads, dodging the cholla and prickly pear along the way. "That's gonna make a good pony," he thought, as the young rider and his mount crouched to a stop next to Bud.

"How's the river look?" Bud asked. "Pretty good. The cattle are already watered out - *en repecho*. Senor Bud, I have to tell you something." The boy's nervous angst was obvious. So was the bruise on the side of his face. Bud squinted slightly, more curious than alarmed. "I took your letters, but some men were there. One of them knocked me down – *cabrones*! He took your dollar." Where's the letters?" Bud asked. " Here." The boy pulled the paper bundle from inside his shirt. Eyes squinting, now with calm resolve, "Well", said Bud reflectively, "I'll take care of it." "I'm sorry, Senor Bud, I should have fought." "It's OK. I'll take care of it. My pony's spent. Let's trade and you can go on back to the camp with him. Take it easy with him and let him blow. Do the chores when you get there. I'll see you by dark." The two

cowboys pulled their saddles off and exchanged ponies. Mounted again, the kid turned toward the cow camp several miles east. Bud hit a long trot back upstream toward the little village.

The hardness on Bud Clayton's face would have inspired repentance from anyone who laid eyes on him as he entered the village. His little cowhorse hit a slow trotting cadence up the wide dirt street toward the post office. Several yards behind horse and rider, a rocky bluff, some 20 feet high, overlooked the river. The loose dust of the street in front of the post office boiled up around the horse's black pasterns as he shuffled to a stop. Bud threw the bridle reins over the hitching rail and stepped up on the porch.

He entered the doorway and noticed three men huddled around a table with a half-empty whiskey bottle perched between them. They glared drunkenly at this gringo stranger. He paid no attention to them until he was in the middle of the room, in front of the postal counter. The men had gone back to their whiskey-laden debate when Bud turned around with a cold look in his eye, pulling his .45 Colt from its holster. Pointing it above his head, he pulled the trigger. As the bullet passed through the stamped tin ceiling, the explosion rocked the local drunks back in wide-eyed shock, one falling out of his chair, knocking the whiskey bottle to the floor. Fine dirt fell through gaps between the ceiling and

wall onto the store's proprietor who had jumped behind his counter. "I want the son-of-a-bitch that took that dollar!" Bud declared, bringing his six-shooter around toward the table.

One of the men scrambled for the door, not even touching the porch as he left the building and ran headlong into the dirt street, the tied horse spooking and jumping aside. Bud stepped out the door and watched the man scamper away, looking over his shoulder like he knew he was about to be shot. His eyes were locked on Bud all the way down the street, the fear on his face almost cartoonish. The last thing Bud saw was the man's bulging eyes, pumping elbows, and flying knees as he suddenly dropped out of sight.

Curious at the outcome, Bud stepped on his bronc and cantered over to the Gallinas bank below the rocky bluff where the fleeing drunk disappeared. There he was, on the ground, half in and half out of the shallow river water. He wasn't moving, but he didn't look dead.

Bud dismounted and leaned over the prostrate form at his feet. The former bully groaned and tried to sit up. It looked like he might have a broken arm. Bud figured the care side of this event would need to rest with the locals, so he fished around in the man's pockets until he found the dollar, or at least a dollar to replace the purloined one. He mounted back up and, before turning away, calmly advised the vanquished one, "Don't take what isn't yours -- and don't abuse my friends."

The little horse wheeled on his cue and started back up the trail around the bluff and onto the street. The thief's compadres were standing wide-eyed out front of the store poised for an escape from this gringo horseman from hell. As he rode toward the store, they scurried far around him in the direction of the rocky bluff to find their friend. The little horse balked as he approached the building, not sure what next might charge out that door. Bud stepped off and once again entered the post office. He set his wad of letters and the dollar on the counter in front of the terrified postmaster, and politely waited for change. When the transaction was completed he sauntered out the door into the afternoon sunlight. Drawing up the reins to mount his pony, he looked across the village and down the dusty thoroughfare. Nobody was in sight, other than the two local toughs slinking away toward the river. Bud swung his leg over the bronc and pointed him eastward, leaving the

village behind, all business for the day completed.

As he rode away Bud's mind turned to the important things. The incident was put away, unimportant history, as he considered work to be done over the next few days. He still had some horses to get started. If it wasn't plumb dark when he got back to camp, he would run 'em in. He and the boy would get an early start in the morning. The warm late afternoon was turning pleasant as their shadow reached out ahead of them onto the trail. He smiled as he noticed the bay bronc hitting a nice little running walk, a gait not many horses can pick up. "Some day," Bud Clayton mused, "I'll do other things, maybe ... some other day.

***

*Bud & Bess, 1948*

# CHAPTER 3

## LITTLE RED

Anyone one who spent some part of life around good horses preserves one or two in memory. Maybe it was the best cowpony, the closest companion, the loyal workmate. Maybe the looks, or the speed, or the ride. Maybe the action, the cow sense. Good cowboys and good cowhorses are often inextricable, their stories blurring into speculation of which really did the deed or saved the day. I am blessed, my mind loaded with a lifetime of names and images of horses that had plied their trade under my kack, some of them pretty special: Pete, Skeet, Peter Waggoner, Button, Keno-Red, Ebony, Peanuts, J-Waggoner, Seneca, many more. But there is always one that emerges from the mists of memory, still in charge, still declaring that I was only along for the ride, and only then if I was man enough.

The Culbertson outfit ran its own band of mares, raising well-bred mounts to cover the

rocks and rills on 150,000 acres spread out over 5 ranches. There were some 20 colts in the 1951 crop. One they called Little Red. History on the bay colt's sire side revealed Sheik, son of Peter McCue, to be his great-grandfather. His mother was a leggy bay named Keno Marie. Her mother was simply called "the Bay Mare" on her papers – the family tree ended there. The colt was deep russet-red, star on his forehead, with black mane and tail, but unlike most bays he lacked the usual black points down his legs.

Something about the colt caught my Dad's eye right away. He was a good looking: solid, well made, but it was more - maybe the no-nonsense confidence in his eye. Entering his third year, ready to break, Dad picked him out for his own string, handing the handsome young horse over to Nick Lecompte, a young cowboy breaking horses for the Park Springs, to get him started right. Nick was an uncanny horseman, able to bring a bronc quickly around as a willing companion and learner. Nick and Little Red pal'd up pretty quick, and trust and confidence came together. After some time in a hackamore, the colt was showing a strong constitution, with plenty of "cow" and plenty of persistence; all ingredients for a cowboy's reliable partner. It wasn't long before Nick had his rope down, showing the intelligent little bay how to handle a critter on the other end of it.

Sometimes Nick's fearlessness would buy a little unexpected trouble, like the day the crew was prowling the winding canyon of the Aguilar, rugged cedar and sandstone terrain that could hide a cow, or a lot of cows, in its brushy cover. My brother Bill, 11 years old, was part of the works that day, riding a good palomino everybody called Pete. The cowboys were scattered in the canyon bottom and up on the Shelly Hays ridge, looking for a bull that had dodged the gather a few days before. The big Hereford had been spilled enough times over the years to make him pretty smart. He was also known for his surly nature and was usually on the fight, true to his Prince Domino bloodline, making him a danger in tight places like the rugged little scrub oak and pinon draws of the Aguilar. If they jumped him, the plan was to drive the bull hard and fast toward the gate in the canyon that opened to the lower part of the east mesa pasture. If he turned to fight, they would catch the bull and lead him out on two or maybe three ropes so he couldn't hook any of the horses.

Nick and Little Red were out of sight, somewhere far ahead of the rest, winding down off the Shelly Hays ridge. The rest of the crew had linked up in the canyon when they heard crashing and the unmistakable crack of breaking branches. Spurring toward the noise, they rounded a point in the canyon to find the bull fighting the end of a rope stretched out from a dense juniper. On the

other side they discovered Nick and his little hackamore bronc pulled into the thick greenery, pinned against a low fork of the tree. Nick was unable to get off the colt in the tangle and, amused at his own predicament, was soothing a nervous Little Red out of the urge to panic. One of cowboys threw his loop around the bull's horns and turned him back far enough to give Nick the slack he needed to pull his horn knot loose and back Red out of the mess. The bay bronc, with a little coaxing and assurance, had stayed cool in a tight spot. They pitched Nick's rope to a second rider and started with the battling captive toward the East Mesa gate, laughing and teasing Nick over the inventive way he stops bulls.

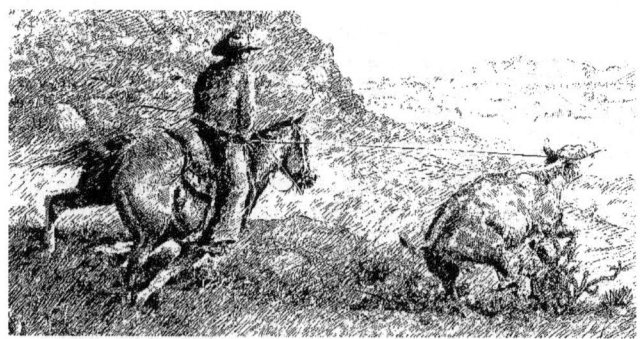

Following, Nick and Billy rode in a comfortable walk and visited. They were pals. A lot of men, for their own reasons, feared Nick LeCompte; and rightfully so. Kids and horses never did, and he seemed to have the same confident trusted connection with both. "Why'd you catch that bull on such a little

bronc?" Billy asked. "… Didn't want 'im to get away." "But he tangled you up in a tree. How come you didn't just cut the rope?" With his handsome mischievous smile, Nick retorted, "It's a brand new rope. Besides, ole Red and I knew you'd be along after while to save us." Billy, considering the weight of Nick's faith in him, turned his serious gaze back toward the bull and the other cowboys ahead passing a stand of cottonwoods on the creek-bank, golden in the fall afternoon sun. Nick laughed, carefree, as the two compadres leaned Red and Pete into a trot to catch up.

Five or six months into his education, Little Red was gentling well, but he carried a subtle no-funny-business demeanor not far beneath the skin. Little Red was going to be exceptional, and Dad decided to send him to a well known cutting horse trainer in Dalhart to put a fine tune on this instrument. Expectations were great, the idea of a solid ranch horse finished with the finer points of a professional cutter. Maybe they would even show him in competition for a while. So, young Little Red loaded up in an open-top ranch trailer to take the 200 mile ride to Weldon McConnell's stables at Dalhart, Texas.

In a few days the Park Springs cowboys saw dust rising above the long dirt road that meandered in from the highway. It was the same pickup and trailer hauling the same little blood-russet bronc. His spare black mane

yielded in the changing fall wind as the rig came around the crest of the little hilltop sheltering the ranch headquarters, but there was no yield in his eye. The trainer had sent Little Red home, declaring he didn't want to waste his time on an incorrigible colt. But Dalhart was a small town, and word traveled easily among horsemen and ranchers. The real story found its way to Park Springs almost sooner than the horse did.

Even before his trip to Texas the athletic bronc had taken quickly to working cattle, and was frowning down on a big yearling in front of him in the cutting pen, when Weldon spurred him quick and hard just ahead of the cinch, a trademark "training technique" of his. He expected the colt to jump even quicker into the turn with the steer, but there was no future in that idea. Red jumped alright, into a bucking rage, taking a twisting neck-snapping course over the befuddled steer to the opposite side of the corral. The rider lifted skyward from the saddle, boots over hat, tumbling high over the fence and landing in an unceremonious pile on the ground outside. Looking up from under his own crumpled body, the elite cutting horse trainer beheld roiling chaos in the corral, Little Red pitching hard along the fencelines, stirrups clapping above the saddle as the horse appeared and disappeared in the leaping splitting mob of cattle; evidence that, this time, his famous training style didn't work too good. After finding his hat and his ability to stand straight,

he hobbled away, proclaiming the colt untrainable and unworthy of cutting horse society. Now the bay horse was home, none the worse for wear, but with a new shade of intolerance in his nature that would never go away.

Back on the ranch Little Red became, under my father's hand, one of the really good cowponies of my memory. Maybe Dad over his years had known some that were better, like Pat, or Town Boy, or others he used to talk about, but Little Red was always every bit my idea of a cow horse. Just under 15 hands, Little Red was not big, but he felt like it under the saddle. Well conformed, on an angular frame that masked remarkable strength, he was fast, clear-footed, and agile, his surging stride producing jarring power. His high withers tied to a powerful wide back and long hip, with red legs joined to iron-black hooves that were not easy to drive a horseshoe nail into. His black mane and tail were spare, as was his condition. In his life I never saw him fat, whether rode hard or not. A handsome horse, his clean-cut head joined a long slender neck whose close hanging mane never grew longer than 7 or 8 inches. When on the move he always carried his head low, lower than any horse I had ever ridden; not like a show-ring pleasure horse, but rather like a hunter – a wolf in pursuit. His bottomless dark eyes and the set of his ears revealed a confident, not-to-be-tinkered with, all-

business authority. Always a reliable cowhorse; but after Dalhart, never a friend.

Cowboys are assigned the horses they ride and care for, and nobody else has privilege on a man's string. Red was my father's, and he rode him pretty much exclusively for several years. Dad was a graceful horseman, and there was a natural bond in their blended movement, the relaxed straight-sitting rider and the consummate powerful cowhorse. These two were mentors in the cowboy education of my childhood as I followed them over uncounted miles and all manner of terrain. Sometimes on black moonless mornings the only thing visible ahead of me would be tiny sparks dancing off Red's horseshoes on the rocks as the crew moved down rough canyon trails, the only noise the uneven rhythm of hoofbeats on sandstone breaks and the occasional rolling snort of a horse anticipating the unknown. There were exciting and sometimes terrifying chases after wild high horned cows with nines in their tails, me trying to keep up in the crashing brush and rolling rocks. But sons follow fathers, and I just kept feeding old Punkin the reins and trusting them – my horse, Little Red, and my dad - to bring us out the other end of it all in one piece. They always did. The cows would usually lose and we would usually win, because Little Red, the wolf, refused to lose his quarry.

Little Red's train-the-trainer incident in Dalhart was not his last dance, but unlike a lot of horses that in their youth had bucked somebody off, he didn't spoil, wanting to pitch whenever saddled up. Red would hold his temper for months, even years, without breaking in two, but whenever he arrived at the moment of his choosing, somebody was about to be unpacked. I was about nine years old when, up in the Martinez Trap, Con Jackson and brother Bill and I watched Dad literally cartwheel off the left side of Little Red after missing a loop on a cow. The best we could figure, the horse had kicked a tumbleweed up against his belly. Dad remounted and roped the cow, the horse falling in and scoring the cow perfectly, and as the rope stretched he anchored himself for the pull. Everything back to normal. That's how it was with Red.

Good ranch horses aren't trained. They are made. Cowhorses emerge from a cycling rhythm of the ranch's life tied to the seasons, as it is with the Park Springs, where the caprocks of Mesas Quates gaze down sphinx-like over a vast juniper and pinon covered terrain. Early in the year, baby calves stay close to their reclusive mothers while winter reluctantly loosens its icy hold, and tiny weeds begin to signal a new start. The sun's tentative warmth begins to flirt with south slopes and protected cairns, but ambivalent winds chill the land in fitful attempts to return to the dormant cold. As spring wins out and

begins to coyly show off little wildflowers, the green tint of a promised grass year is announced by the songs of meadowlarks busy re-establishing their own cycle of life. The Gallinas and Aguilar trickle clear and timid before the summer storms upstream turn their courses full and ruddy. Deep moisture and warming days give the weeds and early grasses a start.

Then branding time, the crest of the ranch operation's yearlong cycle. The remuda can be seen on the move, a rider in the lead and one at the rear, 30 horses in a flowing throng on the way to the next campground. Not far behind, the chuckwagon pulled by a little army jeep, and the hoodlum wagon behind an old pickup full of bedrolls, equipment, saddles, and crew, make their way along a rutted feed road. The camp will be set up with fly tight, fires banked, and supper ready by dusk. Branding, a two-week affair at the Park Springs, ritualizes the end of spring and start of summer. The season deepens, and majestic upward billowing clouds drag grey curtains of lifegiving moisture across the land. Long summer days frame undulating tawny-blue waves of grama grass. Buff colored pronghorn babies, many twins, buck and run with blazing speed in broad circling races past spiny palmillas with single stalks of white succulent blossoms, while their browsing mothers scan, wide-eyed, for threats of coyotes or humans in the breaks. Calves, growing strong and fat, play and explore in

little gangs, their baby sitter guarding not far away while the rest of the cow herd grazes out across broken cedar-dotted flats in the morning sun. Delicate flowers, yellow and white and purple, gleam out from their spiny refuges on the cholla and prickly pear. A long-trotting horse, rider standing in the stirrups, is seen prowling the draws and flats. A curlew, calling out protective warning, flies aggressively over the intruder too near her prairie nest.

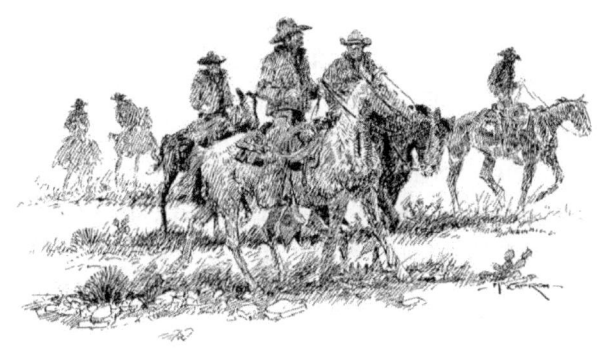

After a time, fall looms beyond the horizon. V-shaped southbound squadrons of geese and cranes course high above the meandering route of the Gallinas River turning gold where the cottonwoods and willows are congregated and where the tamaracks line the banks, and the dry air feels cool and pleasant. Dust rises from the shipping pens, where the bawling chorus of separated cows and calves declares the end of a season. The bull battery is retired to the Chaperito trap,

and the cows will be culled and scattered to their winter pastures.  The fall equinox blows with nervous anticipation of the fading retreat into a cold melancholy wait for the lifecycle to turn again.  Gray-tentacled alamos will point their frosted fingers at the unremitting green of junipers and pinons scattered across yellow-tan grass plains and layered blue-gray horizons under a fickle winter sky.  Coming snows will impulsively invade the dormant ground and recede in a long wait for spring.  And so - the rhythm continues.

That is, if the drought doesn't come.  When the promise of a grass year is broken, the stubborn ground refuses to release the green color of life.  The hot breath of bleak demons predicts the end, the sky refuses its succor, and the soul is tested.  But then, the rains come the day you need them the worst – the day before you give up.  And then – the rhythm returns.

It is a pattern of life men and horses tie themselves to, and in that cadence Little Red grew more solid with every experience in every passing season.  Fast, surefooted and smart, Red made any rider a good hand, yet seemed to treat him as little more than a passenger.  He moved powerfully and quick, forcing his rider to screw down hard and tight when after wild cattle in the brush or working the herd.

He showed to be a cowhorse, rider on or rider off, like the day the men were working cattle at the Chaperito corrals. Dad volunteered to lope back across the pasture to get the pickup and trailer to load up a couple of culls. The men would strike out horseback for home as soon as the culls were penned and the herd turned loose. At the Palmilla Well, Dad dismounted and led Little Red through the gate into the next pasture. Leaving the saddle cinched up, he pulled the bridle off and turned Red loose, knowing he would head homeward and be waiting to be let through at the horse pasture gate. Dad hopped in the pickup and headed with trailer in tow for the Chaperito pens to load out. The men were well on their way home. Riding within sight of the horse pasture gate they could see the horse waiting, but there was more. On his way, Little Red had gathered a little bunch of cows and had them held up in the fence corner, backing his ears at the puzzled bovines and blocking their escape.

By the time I was a teenager I'd have Red in my string from time to time. Whenever I swung a saddle up on his back I knew I would be well mounted that day, and however good or bad a hand I may have been, Little Red evened the field. I also knew to watch him. He was sometimes cold-shouldered but, being soft-mouthed, it was usually easy to keep his head coaxed up as we started out in the morning. As long as I let the steam out slow, I would be horseback.

In the brush, Little Red would stalk like a wolf, moving with cunning resolve. When he saw or sensed cattle hiding in the thickets, muscles tightened and ears pricked forward. When they jumped from their hiding place he surged forward with startling strength and quickness. The race was on.

Working a herd, the aggressive cowhorse would center down on the cow to be cut out and drive her away from the bunch. Instead of giving space and playing the animal, he would charge, almost like an attack, not giving the cow time think about how to get back to the herd. He was too quick to let the cow slink back under him, not an easy maneuver for a horse but no problem for Red. The rider's challenge was to hang his reins slack and stay in the middle of the horse. Riding into the bunch on a horse like Little Red, watched by the men holding herd, stirred the rider to believe he was master of the day, among a privileged class.

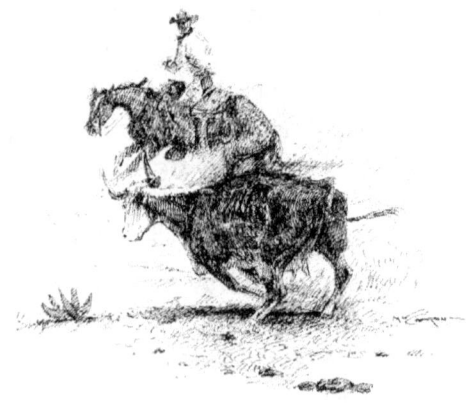

He was fast – and cool; like the day we finished branding at the Troncon Negro, a set of picket corrals on the fenceline between the Mujeres and La Liendre pastures, built around a windmill that watered both. Next camp was the Deep Tank corrals in the Aguilar pasture, several miles away, across a canyon named for the spring near its head known as Las Mujeres. The men went with the caravan to help get set up at the deep tank pens. I would bring the horses by myself. The equipment rolled out while I stayed back making sure the corral and everything else was in order before leaving. It was enjoyable being alone with just the horses. The remuda was grazing in the adjoining horse trap, so Red and I trotted around the bunch and eased them through the pasture gate. As I was pulling the wire gate closed, the cavvy lit out on the road that ran the narrow length between the high mesa and the canyon, getting a long running head start. I was going to need to get them cut off the road onto the trail leading across the canyon where the Mujeres Spring seeped out and the shallow slope allowed an easy crossing. It would save a couple of miles and a lot of time, but the horses were getting away, so I pulled my hat brim down hard, hopped for the stirrup, and turned my mount toward the fast departing horses in the distance.

Sudden forward-ripping power surged under me, accelerating with every stride. By the time we caught up with them we were flying,

hooves seeming to barely touch the rocky eroded ground alongside the thundering mob on the road. Had he stumbled we would probably still be rolling. But he didn't. Little Red stretched past the loose horses one by one, dispatching the earth beneath us with long reaching leaps until I was able to wave my coiled rope in the faces of the leaders. We leapt up on the dirt road and pressured the lead horses to slow down just in time to catch the trail's intersection, wheeling to a stop and facing the remuda as they turned downhill toward the crossing. After a chase like that, most horses would have been keyed way up and hard to handle, wanting to run with the bunch. Little Red stood calm and quiet, betraying nothing of the wild race except for his flared nostrils and heaving sides. His was always an all business, "all in a day's work," attitude.

Good in the herd and good in the chase, he also was good, but unforgiving, on the rope. He could handle about any size and temperament of bovine and could bed-em down if you needed, but his own temper always lived near the surface, and Little Red was not something you would want to be tangled to if things went wrong. With this pony, 'pay attention and anticipate the wreck' was a good proverb to live by. I did, and for many years didn't have to face that other thing he was good at - that thing he would someday show me.

The years passed, and I moved on to other pursuits, to college for a couple of years and then to the military. Stationed for a while at Cannon Air Force Base near Clovis, I was not far from home. Branding time came, and on Friday afternoon I turned west out of Cannon headed for the Park Springs, 150 miles away. My brother Cary was getting things ready, and as we made plans that night for the South Pasture and Lower River, he assigned me a couple of horses for the weekend's work; Little Red and Keno, a younger half brother that had been in my own string for years. Dad spoke up; "Ole Red's 18 now, getting' a little older. Take the short circle on him tomorrow. That'll be the easier pasture. He deserves a light day." "Sure", I responded.

The dark horizon at our back was turning orange as we trotted out from the headquarters through the little "schoolhouse trap" and into the South Pasture. At the gate, I stepped off and tightened the cinch a couple of holes, while old Red acted like he still hadn't woke up that morning. Cary took the rest of the men and kicked into a lope for the back side of the pasture beyond the bald round topped hills, while I took a slow gait toward middle of the pasture where a wide draw meanders out of the hills and opens onto the flats at the South Well. I had a lot of time while the crew scattered along the back of the pasture. The cattle would string out of the hills toward the windmill, where I would loose-herd them until we were ready to drive 'em to

the HQ pens. I touched Little Red into a lope, just to loosen him up a bit and break a little sweat, then we settled into a slow shuffling trot. It was a bright warm morning and it felt good to be horseback, away from the flight-line and the military for a couple of days.

Cattle drifted in from several directions, congregating at the South Well for a drink before moving on. Bulls would stop and stiffen with heads lowered, threatening each other and pawing the dirt over their backs, occasionally clashing with unexpected quickness and power. I loped leisurely around the leaders trailing out, easing them back toward the windmill. When all the cattle and cowboys were together, we pointed the drive to the headquarters, passing by a town of prairie dogs indignantly standing and pitching their shrill barks at this procession of encroachers. Arriving, we pushed the cattle through the gates and up a long wide lot to the upper end that was fenced off about the right size for a good branding pen.

There was a bustle of activity in the growing noise of bawling cattle and men rolling the branding wagon in and setting up. As they started stringing cows back out the gate and holding the calves back, I stepped back up on Little Red and eased past the entrance, shaking out a loop in case a calf might get past and escape with the cows. Red and I sat quietly outside the gate, at rest on the edge of the boiling dust and noise, my rope tied off, its

loop draped over my leg to the stirrup. The sorrel stream of bald-faced cows passed by us, pushing and snorting to breach the narrow passage to the expanse of the long wide water lot. Then, among the hustling cows, a calf raced through the gate.

Leaning up and touching spurs to my mount, I pointing him at the calf. He fell in behind the running target, cows scattering out of the way. In a sporting mood, I was standing in the stirrups, swinging my loop fast as we closed on the calf. As soon as Red had him scored I took my shot and the loop made a swiping figure eight as it settled around the calf's neck. I never got to jerk the slack.

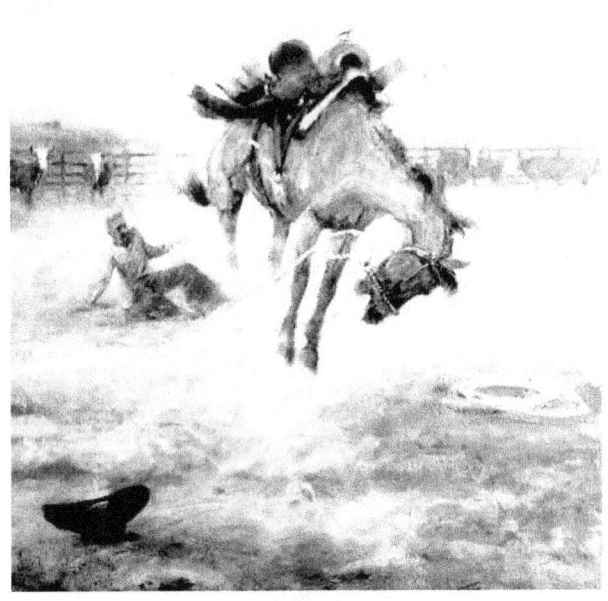

It was as if an explosion went off under me. The last thing I saw clearly was the calf running through the loop. Then, twisting hammering confusion. My instinctive reaction was to screw down and ride, but I was bucked off from the start. Both stirrups blew as the saddle wrenched away. Coming to earth I saw a hind leg and felt a blow to my face, hitting the ground hard and watching Little Red jump away. I could feel the dangerous zzzzip of the lariat slipping around and then off my boot top as the raging bay bucked over the top of the confused crowd of cows ahead of him. Painfully getting up on one knee to regain my bearings, I saw Red in the far end of the water lot, settling into a half bucking half running stride, rope bouncing and dragging, bridle reins flying in the breeze, and my dad roping him around the neck.

My attention turned back to myself as I tasted blood and my tongue felt ragged holes where my upper teeth had punctured through my lower lip. I stood as Dad loped toward me leading Little Red. I gathered the reins and stiffly mounted back up. Spotting the calf in a bunch of cows near the far corner, I spurred Red into a trot, coiling the rope and building a new loop. As the calf bolted from the corner I hoolianned him, turned toward the branding pen and pulled him dancing and bawling through the gate, trying to act like I wasn't in pain. Little Red was back to business as usual, but I could feel a seething between my knees.

Dehorners and knives were sharp, vaccine guns filled, and flankers standing by. The roar of the propane burner in the well-casing heater blended with the bawling of calves and their mothers on opposite sides of the fence. Dad said, with a subtle tinge of humor, "why don't you drag a few on old Red. That'll do him some good."  I reset my saddle and cinched up tight, then shortened up my rope and tied it to the horn, tucking the rope's excess tail under the right stirrup fender and behind the cantle.  Loosely tying one rein out of the way around my horse's throatlatch, I tied the end of the one I would use into the opposite ring of the bits, making a sort of "roping rein" that could rest on the horse's neck if need be without me holding it. I stepped up on Little Red and glanced over to the iron man at the stove. He nodded, letting me know the irons were hot and ready. The pounding pain in my jaw had turned into a tender ache as I rode quietly into the crowd of calves.  In the herd, Red slinked slow and smooth occasionally nodding into the bunch to make the calves break up and move, but he seemed to have a little bit of a stiff arch in his neck and was watching me more than his work. Swinging my rope in slow tempo I laid a trap, the loop flopping under the flank of the first calf and snagging both hind feet.  Red ducked under the rope toward the branding fire and the action was started. We dragged the calf near the fire as the flankers stepped in behind us, one grabbing the rope and one

the tail, jerked the struggling calf to the ground and held him as all the specialists crowded around, smoke rising, horns removed, injections and all the rest. I snatched another calf, and then another and another, and the branding corral was quickly in its busy routine.

That stiff neck and those sullen rear facing ears persisted. The more calves I dragged to the fire, the more Little Red's rebelliousness surfaced. He was swelled up and taking an occasional little angry hop, looking back and challenging his rider. I took both reins back into my hand and untied the rope knot from the saddlehorn, dallying up when I heeled the calves so I could get rid of the rope in case he broke in two.

Under my own skin I was angry. Angry at this horse for trapping me like that. Angry at myself for not making any better showing than I did. "I can ride this horse", I thought. "If I have the jump on him I can ride 'im." I picked up the heels on a big bull calf and, when he hit the end of the rope, Red scotched and took a little crow hop. That was enough for me. I pulled the dally off and threw the rope away, cramming my feet in the stirrups and, pitching him the slack, set in for the ride. Little Red rose like an eruption, slamming the saddle into me and taking a high twisting snapping jump, then another and more. I was leaning back hard to keep the momentum from throwing me forward and down. My

instincts were shouting, "find the front of the saddle! Drive your feet in the stirrups! Stay in the middle! Get ahead of him! Stay in the middle!""

There was nothing pretty about it. No free hand in the air. No spurs reaching for the shoulders in confident rhythm. I was riding a string of collisions across the corral; hurtling bone jarring punishment scattering men and cattle until we were in the upper corner of the pen. There Red dove into a spin, head out of sight, jumping leftward and high with gut straining power, coming down steep and hitting the hard ground in crashing encounters. Every time Red snapped in the top of the jump I lost the saddle horn. Every time he hit the ground my feet blew away from him. I kept twisting leftward, spurring on the outside, trying to keep up in the whirling storm. Voices rising up in the confusion; "Ride 'im! Ride 'im!" A mix of fences cattle and men blurred in the periphery. With every high hammering turn he was edging slightly ahead of me, taking my seat away bit by bit.

Then, we separated. I was rising and the horse was descending away in a spin under me. For a second I was weightless; then as quickly I was back in the maelstrom looking up at the horse bucking and turning above me. Hitting the ground I heard myself exclaim "The son-of-a-bitch did it again!" Hooves hit next to me, then passed over. Bucking away, Red almost ran a man down, then jumped over the top of the branding stove and wreaked his terror down the middle of the corral.

I limped over to pick my lariat off the ground. Little Red was standing off to the side of the pen, pouting, finished with his tantrum. I coiled the rope and painfully mounted back up, and we went back into the herd. There

were still a lot of calves to brand and the works had to keep moving. Soring up, I felt like something had busted in me, and I was having a hard time moving my arm well enough to heel the calves. Red acted like he wasn't finished, still stiff necked and challenging. Moving through the herd and catching another calf by just one foot, I pondered this recalcitrant 18 year old. He'd shown me that other thing he was good at. I guess I wasn't surprised that he finally would. Pain was getting in the way of my doing any good with a rope. A resigned half-smile briefly crossed my swelling lips as I delivered the calf to the flankers and conceded under my breath, "looks like you win." I handed off to another roper and tied Red to the fence.

There is a familiar old saying that there was never a horse who couldn't be rode or a cowboy who couldn't be throwed. I believe there were men who could ride Little Red, but I don't think any of them worked for the Park Springs during this blood-bay's watch. But, as notorious a bucking horse as he was, it was Little Red the cowpony that stood apart, remembered with awe and respect by those who knew him. His independent, solid, determined style has not often been matched in the ranch country, maybe never. Sometimes, when I try to recall the times in my life when I most felt the raw sensation of undiluted freedom, Little Red emerges from the mists of the past between my knees, loose reined, almost flying, routing the rugged

obstacles, running down the fleeing target, both of us indifferent to the illusory notion of safety or caution.

Little Red was eventually retired on the ranch to quietly lead his life to its end. Years later, when he died, my father buried him in the meadow below the lake at the Park Springs headquarters. In the shade of old spreading trees, the air made pleasant by cool breezes and fragrant grasses and songs of birds making their homes in the reeds, it is an ironically peaceful resting place for a horse that had lived a life of wild action in harsh surroundings. But it's the right place; the place where the one who knew him best wanted him to be.

Quiet meadow ground still holds the bones, and the distant memory, of a little no-nonsense bay cowpony esteemed by every cowboy who ever saddled him up, knowing they'll not see another – not like Little Red.

***

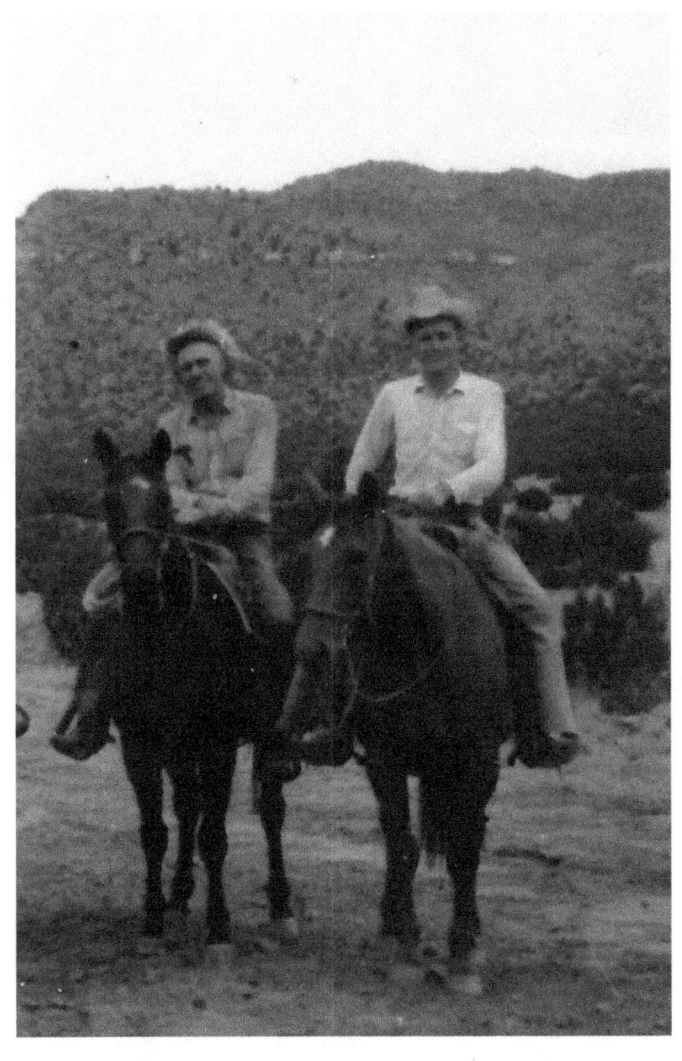

**Dad on Wag, me on Little Red**

# CHAPTER 4

# COLONEL BOB SCOTT

*This story is built around an incident during the Vietnam War. I first heard about it early in my military hitch from a weapons troop who had been on scene when it occurred, and then sometime later from a conversation shared by a United States Senator. Their accounts may or may not have been complete, but the principles remain true and certain.*

\*\*

It was nearing 0930 hrs and the sun was already bearing down hard on the steamy runways. The humid skies overhead were clear, but with developing rainstorms north and east. Haze below the cloudline rendered the horizon almost invisible. It was a regular morning at Takhli Royal Thai Air Force Base, Thailand. The year was 1967.

The day's first launch of the 355th Tactical Fighter Wing's F-105 strike aircraft had rolled out at 0620 without a hitch. The flightline was empty of planes except for a few under repair and some on "standby alert". The birds

should be due back pretty soon.  Subtle evidence of their anticipated arrival could be seen on base.  Trailers, some carrying racks of bombs and others with air to air and air to ground missiles had already been parked near the edge of the flightline, ready to be installed on the aircraft when they returned.  In the sweltering tropical heat, most of the ground crew personnel were in t-shirts.  Crew chiefs, with intercom/ear protectors hanging around their necks were beginning to tidy their areas and place equipment in the correct positions at each parking spot.  At the ends of the runways, the de-arm crews began looking toward the skies off to the north.  The weapons troops were casually picking up their toolbelts and gathering on the flightline by their "jammers".  The next frag order was already on the greaseboard and the load crews had their work-orders in hand, ready for the turn-around.  For most aircraft it would be more of the same: 500 pound bombs on multiple ejection racks centerline and inboard; AIM-9 air-to-air missiles outboard; Check and reload the 20mm M-61 guns.

The mach-2 F-105 Thunderchief was a big, quick fighter-bomber. Originally designed to deliver tactical nuclear weapons, it was doing combat service in Southeast Asia, speeding conventional bomb loads to targets in "Route Package Six", whose perimeter included North Vietnam's capitol, Hanoi, and Haiphong Harbor, the country's largest seaport.  It was a speed demon, but not as agile a dogfighter

as the Russian MIG-17. Victories in those duels were hard won, due to superior determined pilots who knew how to handle these big fast weapon platforms – "Thud Drivers", they were dubbed.

Proof of tough work-days was increasingly obvious: frequent battle damage; airplanes "returning winchester" - armament, missiles, and ammunition completely expended; sometimes a crew chief standing at an empty parking spot after flight recovery. It was getting rough up there, and the ground crews, though not in the cockpit, felt a big stake in the game. They did their jobs diligently and well, making sure the pilots were strapped to dependable aircraft and could push the button on dependable weapons. Every day, the smoke of each bird's main tires hitting Takhli's runways was a welcome sight.

For the most part, news media back home weren't paying much respect to the difficulties of these missions or the heroics of the pilots flying out of Thailand into enemy skies filled with flak, MIGs, and telephone-pole sized missiles. The air war was no respecter of rank or command, putting every officer into harm's way, side by side on the wing with every other. The targets they were assigned were as treacherous as any in history to reach and destroy. The strain on the pilots was extreme, but they kept flying. They kept assaulting the enemy deep in his territory. Losses were high, and news of casualties, MIAs, and pilots in the

hands of the enemy was arriving back home every day. By the time of the war's end, almost half the F-105s built would be lost. But this day, here at Takhli, everything just boiled down to the mission. There was work to do to keep the birds in the air and the weapons readied for the targets.

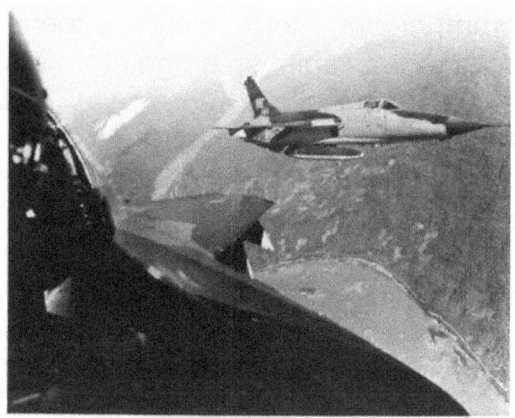

*"... returning winchester"*

They could be spotted long before the familiar engine roar began to announce their return. From the haze over the northeastern horizon emerged black dots growing into familiar Thunderchief silhouettes in 4-bird formations. Arriving at about 1000 feet above ground level, the first flight coursed over the length of the runway, the lead plane suddenly banking left and descending in a wide spiral to final approach on runway 18, each aircraft of the flight precisely following in turn. As they touched down, their drogue chutes popped

open and trailed like long bridle reins pulling warhorses to a walk.

The fighters taxied to the flightline and were signaled by the ground crew chiefs to a stop. Engines were shutting down and ground crews immediately setting to work, preparing them for turn-around as the "tire kickers" ran up the ladders to assist the pilots out of the cockpits.  The normalcy of the bustling activity was broken by the wing vice-commander who, with some intensity, told a crew chief he wanted to see the photo troop taking the strike film out of the number 2 aircraft. "Yes sir!" He summoned the photo troop, a young t-shirted GI. "What's your rank, son?" asked the Colonel. "I'm a sergeant, sir." "How would you like to make staff?" "I can't, sir. I've just sewed this one on." "Don't worry about that", he said with characteristic calm. Peering at the aircraft, he said "Destroy that strike film and you'll be a staff sergeant tomorrow." The photo troop walked over to the wingman's bird, popped the film canister out, and "accidentally" dropped it, the film unrolling across the flightline.

<p align="center">***</p>

I enlisted in the US Air Force in 1968, restless and in need of a little growing up. Up till then, nothing had been important in my life that was not part of the ranch where I had spent my life. School had been of little interest, having

chosen a world surrounded by grama grass and cedar horizons, and believing a good string of horses at hand and good cattle under my care to be enough, I was nevertheless being stalked by unexplainable restlessness – and the Draft Board. I think if a poll were taken the consensus would be that those horizons needed a little broadening, my vote being with the majority. I arrived at Amarillo Air Force Base for basic training, coming off two months of calving out 400 heifers, having pretty much worked around the clock, sleeping and eating when we had a spare chance. Daily drill, PT, three meals a day, and regular sleep put 20 pounds on my frame in six weeks. Military life introduced a lot of new concepts, although discipline and respect for authority were already familiar. My lessons learned at the Cow Outfit School of Hard Knocks were valuable in this new environment: make a hand; pay attention; don't get in the way; the boss is in charge; stay loyal to the outfit; the job at hand - the mission - is what counts.

After Amarillo, I was stationed at Lowry AFB, Colorado, training as a weapons troop, learning the bombs, guns, and missiles of delivery platforms like the F-100 Super-Saber, the F-4 Phantom, and the F-105 Thunderchief. There, a weapons instructor fresh back from Takhli told the story of the encounter between the colonel and the photo troop who made staff.

I left Lowry with orders for Cannon Air Force base, near Clovis, New Mexico. It was home for the 27th Tactical Fighter Wing, an F-100 outfit. Clovis, a cattle town central to the agricultural economy in Texas and New Mexico, was very familiar to me, and I was glad to have my cultural roots within reach right outside the base security gate, and the home ranch only 150 miles away.

My father, a leader in cattle industry affairs, frequently spent time in Clovis. One day he called me to say he was coming to town to give a talk at the grand opening of the new livestock market and asked if I could meet him there. I would be off duty that day, so I said "sure". He said there was someone he wanted to introduce to me. The next day I dropped in on the festivities at the new sale ring, dressed like any of the cowboys and cattlemen there. Soon I spotted my dad in the large crowd. "Come with me. I want you to meet somebody." "Who is it?" I asked. He replied, "Colonel Bob Scott."

I must have looked like a saddlehorse balking at a badger hole. "I can't meet him," I exclaimed. "That's the Division Commander!" There was no reasonable scenario that would put me face to face with this Commander – at least none I was willing to imagine. The man was high ranking, notorious, and way out of my caste. On Base, he was known as "Colonel God", having a huge reputation for being demanding, tough, by-the-book, and

81

no sufferer of fools; a mythic Air Force version of George Patton. I had two stripes on my sleeve and didn't belong in his company; yet there was my father characteristically assuming everything was normal. Well, he insisted in his inimitable good-natured style, so I had the reluctant opportunity to meet Colonel God that day.

Colonel Robert R. Scott was the perfect military representative in that setting, having worked on a family farm in the midwest, steeped in agricultural heritage. His knowledge and enthusiasm for cattle and agriculture, coming from inside a hero's uniform, bred enormous respect in a town like Clovis. He was well spoken, confident, and committed to the ties between the military base and the community. We neared the Colonel in the crowd, and when he turned toward my dad and me I got my first closeup look at this man with the iron fisted reputation.

He was not a large man, and lacked the bigger-than-life square jawed features of a stereotypical 'Steve Canyon'. Without the uniform to give him away I would, at a distance, have picked him to be a professor before I would a fighter pilot. Nevertheless, his straight, slender frame carried the tailored blue testimony of his profession in impeccable order, disclosing "authority" and "duty" in the same visual phrase. Multiple rows of ribbons above the left breast pocket silently spoke stories of battle and honor, and

a small silver eagle rested in perfect spacing on each shoulder.  Under his flag cap, close-cropped graying hair framed a broad forehead and a face that was both open and authoritative, with a smile that was certain and came quickly.  His piercing blue eyes had a far-reaching squint that seemed to be common in combat pilots.  As we shook hands his manner was friendly and genuine, with a natural air of respect.  He appeared glad to meet me and proud to learn that he and I were, as far as he was concerned, in the same line of work.

Colonel Scott and my father became fast friends, and he was a frequent visitor to the ranch.  As a result, the Colonel and I became friends also, traveling on occasion to the Park Springs Ranch for a few days of escape to hunt or ride or simply relax away from the military.  Other officers, including 27th Wing Commander Colonel Frank Buzze, would also sometimes join up at the ranch for a respite with the Culbertsons.

Unconventional weakly describes this relationship between the commander and the airman.  On base there was none.  We were professionals in respective but vastly separate realms of the same world.  I was content to load bombs on the flightline and trust Col. Scott with the Division.  At the ranch, on the other hand, we would all pour a scotch in the evenings, enjoying steaks and good conversation about politics, philosophy,

cattle, and ranching, laced with an occasional understated war story or other remembrance. Then – back to Cannon, back to work.

While on a business trip to Washington DC once, my father was having lunch with New Mexico's Senator Joe Montoya. "Joe," he asked. "… You know Colonel Scott, don't you?" "Sure", the senator said. Dad continued, "It's curious. Bob holds sway over five fighter wings in four states. He obviously enjoys a status in the Air Force like few I've ever heard of. He is, in my estimation, a great man in every way. The man is an Air Division Commander, and three of his wing commanders are generals; yet he's a bird colonel. It doesn't make sense. You have any idea what the story is?" Joe said, "Yes, I do …"

***

The air war over North Vietnam in 1967 was hot and getting hotter. F-4 and F-105 squadrons attacking from bases in Thailand had their hands full with high mission load, little rest and casualties almost every day. Colonel Scott commanded the 355th Tactical Fighter Wing at Takhli, Thailand. Route Package Six, their assigned target territory, was mean-streets for sure. The heroic pilots were leaving the runway by sunup, refueling inflight before crossing the threshold of enemy territory, then dropping low and fast, breaking over the treetops of a shallow

mountain range running northwest to southeast known as Thud Ridge, to strike supply lines and infrastructure near Hanoi and Haiphong Harbor. First in, and last out, were always the "Wild Weasels", specialized F-105s fitted with electronic gear and weaponry for detecting and destroying surface to air missile launch sites.

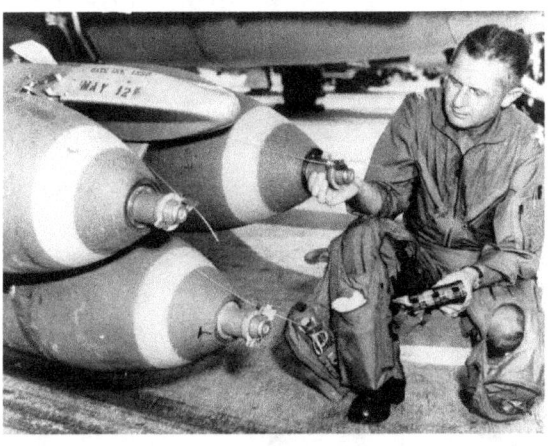

Frustration was as high as the tension and fatigue, The city of Hanoi and the port of Haiphong were off limits to attack, so the enemy grouped anti-aircraft assets behind those arbitrary boundaries and pounded the flights with impunity. Political restraint was taking its toll on the opportunities for victory and the men who would, if they could, seize them. The pilots were constantly in the flak, straining to make out their assigned targets while watching for the telltale flash and contrail of the surface-to-air missiles rising out of the protected areas. Evasion of a launched surface-to-air missile required

nerve, precision, and luck. Skill, training, courage, and sheer determination were the ingredients in the pilots' character that brought the weapons to their assigned mark in these conditions. The pilots got it done, but they knew, every day, they were leaving off-limits targets behind that could bring the enemy to his knees and shorten the war. Unfortunately, the DC beltway warriors were in charge of the targeting, not the commanders.

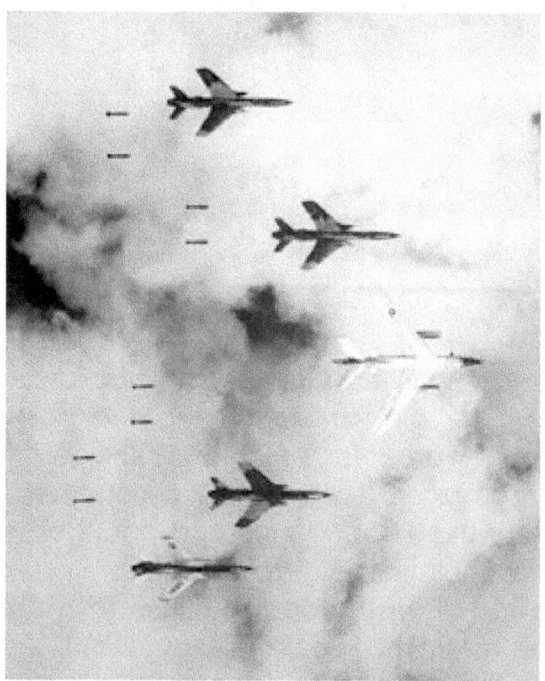

Once the bombs were delivered, the pilots turned their attention to the challenge of getting back home – no small feat. Low on fuel, the flights would head out over the Gulf

of Tonkin in search of the Stratotankers that would give them their inflight top-off before turning back for Takhli. Crossing back over North Vietnam, the gamut of deadly obstacles was as menacing as ever. SAMs took aim, and Soviet built MIG-17 fighters would rise like occasional angry hornets. The 105s could simply outrun the Migs like high school kids at a drag race, but they would often turn and fight, in twisting G-laden maneuvers, positioning on their targets for the M-61 'Vulcan' guns or heat seeking missiles. They sealed the last sortie for a lot of those Soviet fighters. Colonel Bob Scott, call sign "Leech-1" faced off on 26 March 67, marking up a MIG-17 with his 20mm gun.

That was the normal work routine for the 355th, and so it was on one flak infested morning as a flight of Thuds broke through the broken clouds on a bombing run near Haiphong. Besides the flak, they were having to out-manage the SAMs that had avoided destruction by the Wild Weasels when, from the harbor, a big gun near, or maybe on, a Russian "freighter" opened fire. Neither the gun nor the ship was any stranger to the scene, and it was getting to be a frustrating and lethal nuisance. Suddenly, a pilot turned and fell into a steep approach, his wing man tight alongside, toward the harbor, lined up on the gun, and released the full destructive force of his 100 rounds-per-second 20mm gun. As he ascended out of the strafing run, the gun had been silenced, but what would be the

cost? It was an unauthorized and "illegal" action. In the days to follow there would be accusations by the Soviets, denial by the United States, film of the strafing produced by the Soviets, embarrassed acknowledgment by the US, and a full-scale international incident with all the accoutrements of scandal-hungry media, opportunistic politicians, and a mad-as-hell president and pentagon. The beltway warriors were in a frenzy.

Wing Commander Scott was away when word of the incident reached him. He cut his other business short and left immediately for Takhli. Guiding his aircraft back to the base, he pondered those inevitabilities. Two of his pilots had broken ranks and abandoned all training and discipline, taking matters into their own hands and cutting across all the rules. It was a rash and unacceptable action, and these airmen were in real trouble. Colonel Scott would deal with them, and with anybody else who might believe such an action could be tolerated. But he knew another thing he had to do – stay in charge of dealing with the incident. There was going to be trouble in high places, and other people, for other reasons, would want these young officers' heads on a pike.

Back in the old days, before our Lord and Savior came to straighten some of these issues out, it was customary for a village to select a single goat from the herd, go through

fear driven rituals, and at the end of the day assign all the citizens' sins to the goat. Then they would banish the animal from the village, abandoning this sudden and solitary criminal to the wilderness, and to the wolves of the dark. The people then, for a while, felt better about themselves, righteous, with all wrongs comfortably hidden away, and a new sense of innocence in prevail. It wouldn't be long before the Pentagon would initiate an investigation to support a political cure for the problem. Their charge would be simple: find the pilot and bring down upon him all the sins of the "village", assuaging the proxy enemy, and helping everybody – but the pilot – to feel better. As soon as his engines were shutting down, Colonel Scott was on a plan to protect the rash young pilots. He was going to make them wish they were dead; nevertheless, they were courageous airmen – not goats - and didn't deserve the wolves of the dark.

As predicted, in a few days an appointed investigating team, led by a pentagon general whose name is no longer important, arrived. Encountering the wing commander, they got straight to the point, demanding the scalp of the pilot of the F-105 in the Russian film. The answer was as pointed in return – "No." The general made the point that Colonel Scott was being ordered to "investigate" and turn the pilot over. Again, the answer was no.

I imagine the response to their demands went something like, "...I am the Commander of

this wing. I am responsible for all the men in it, their discipline and their protection. These men are flying tough missions under extreme pressure, looking death in the eye every day. I'll not hand one of them over to a committee looking for a scapegoat. As their commander, it stops with me. You know that." He was right, and they knew it. The wing commander was typically designated to investigate such incidents. The General was looking for red meat, not justice, so sidestepped Colonel Scott and took complete control of the investigation himself. The promised sacrifice on the altar of international politics would not be denied. And ... Scott would pay.

In the military, to achieve the rank of general, the candidate must first be selected by a committee of generals known as the Promotion Board. A member of that board, the investigating team leader would exact revenge on this commander who chose his men over the expedience of the beltway power structure. The general was overheard to say that, for as long as he was a member of the promotion board, Scott would not get his star.

Eventually, the investigation revealed the pilots and courts martial were convened, but they only resulted in dismissal with a $600 fine levied for destroying $5.00 worth of government property but, in the doing, plateaued of the career of the Wing Vice Commander.

***

I left Cannon in late 1969 with orders for Danang Airfield, Republic of Vietnam, with a few months' stop-over at MacDill AFB, Florida for training on F-4 Phantoms. One morning while at MacDill I was called to the phone by a rather panicky 2nd lieutenant. It was Colonel Scott on the line. He said he would be flying in to MacDill for a couple of days and wanted to know if we could get together for dinner. Near his ETA I went down to base ops where they would be parking his F-100, and where I saw evidence this was no run-of-the-mill colonel. A red carpet was unrolled to his parking spot and a line of senior officers was awaiting his arrival. Looking up, I saw the familiar Super-Sabre in the landing pattern, with all the 27th TFW squadron colors arrayed in stripes on its tail. He landed, taxied to the apron, and shut down, and the line of officers came to attention when he dismounted. Each of the men in the reception line saluted and shook his hand. A staff car was available for his use, and as soon as he caught my eye he waved me toward it. As we pulled away, a lot of brass was left standing on the curb, no doubt wondering who the heck I was. It was a good visit that evening over drinks and dinner, talking about things back at Cannon and Clovis, the cattle business, the ranch and the family, and my coming assignment in the war zone.

Equidistant between Saigon and Hanoi, Danang Airfield was known by its well earned nickname, "Rocket City". By May of 1970, I was on the flightline there, in the 366th TFW "Gunfighters," loading weapons on F-4Es on 12-hour shifts. Those days in the war zone, letters were the only link with home, except for a single allowed phone call during the tour. In a letter from my folks one day, I read of Colonel Scott's retirement ceremony at Cannon AFB a few weeks previous. It was said to be big, attended by plenty of military and civilian friends, brothers-in arms, and brass from throughout the Air Force. And, indeed, he was still a Colonel.

Robert R. Scott was a military officer unmatched in experience and credentials. He flew in World War II, Korea, and Vietnam, flying more than 300 missions in those three wars, 134 of them over North Vietnam. Colonel Scott was one of only two combat pilots to have kills in both WWII and Vietnam. Between Korea and Vietnam he was test pilot for the F-105 and F-107. All the way, he was trusted with command authority. I doubt that any Air Force officer would have been more solidly qualified to assume high command; the entire department, or for that matter the entire military force, than Bob Scott. A shallow military bureaucrat who had gained the rank of general for reasons unknown, moved to prevent that by withholding a symbol of authority. What the desktop

general could not withhold was the greatness of an individual.

*Colonel Bob Scott, Commander, 355th TFW preflight briefing, Takhli RTAB – 1967*

The collision between a superb military career and a small-minded attempt at retribution caused "Colonel Bob Scott" to become a phrase, a title in itself, that in some ways transcended conventional terms of military rank. Generals' stars did not outweigh its authority, honor, and respect. The real warriors in charge knew the quality of the man, and revealed that respect by entrusting the 832nd Air Division to his charge until the completion of a full and enviable span of service.

***

In 1972 I left active duty and returned, with the love of my life, to the ranch that had never

released its grip on me. The familiar things once again surrounded me – a big open country, good cattle, a good string of horses. Georgia and I made a little rock house on the west side of the ranch our home. I was a cowboy again, doing what I had always wanted, but now, standing on the ground I chose for my life and for my family, I felt a different kind of connection to a much bigger world. During my military hitch I experienced things and made friends, good ones, I would never have expected or predicted, and will never forget. The lessons of a diverse world at war and at peace brought me down a little, hopefully adding a pinch of humility to this character mix.

I saw Bob Scott in California later that same year. He was the test site manager for Fairchild Aircraft, and one Sunday morning he drove Georgia and me from his home in Tehachapi down to Edwards Air Force Base. Pulling a hangar door open, he walked us to his project – the A-10 Thunderbolt, a rough and tough straight-winged tank killer that would soon pick up the nickname "Warthog", and would finally begin to establish its place in history during Operation Desert Storm almost 20 years later. As we stood under the guarding stance of the A-10 and visited, it was clear his confidence and bearing had not changed since the day we met in that crowd of New Mexico cattlemen. Civilian clothes failed to alter the peer of the combat pilot's eyes or hide the presence of a real officer.

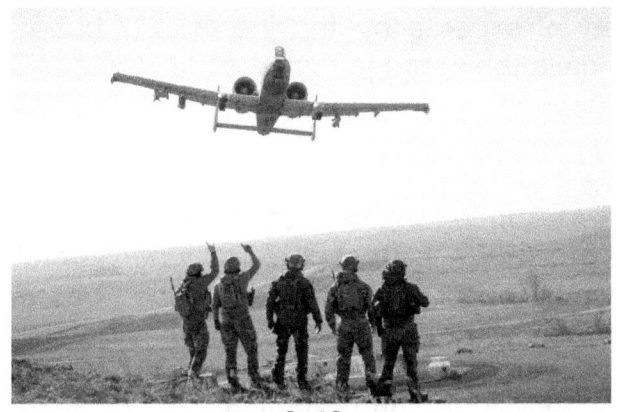
**A-10**

Eventually, Bob, with bride Dorothy, put together a ranch in California, near Tehachapi, taking on a new life as a cattleman. For a while he added a New Mexico ranch to his operations, and we would on rare occasion see him or hear of his whereabouts, but then, over the years, contact faded. I recently learned of his passing in 2006 - "flew west" as he would have said - joining Dorothy who had gone before, at rest on his final mission. Arlington holds another hero.

Bob Scott was never aware that I or my father knew his story. It was not important that he did. Such a thing was not the basis, but simply confirmation, of a friendship and respect grown strong. He never knew his story had become a signpost for me; a reminder that the day might come when standing on principle may cost what we expect from life - a reminder that one must well know those

principles when facing a choice between the safety of expediency and the risks of honor, and have the courage to make that choice.

***

It was a routine morning at Takhli Royal Thai Air Force Base, almost cool in the humid pre-dawn darkness. The sun would soon be up, and the pilots were on their way to the flightline from the preflight briefing. The birds were fueled up and the load crews were covering final checklist items to make sure the weapons and guns were ready and reliable. The ground crew chiefs were readying their areas and positioning the power units for start-up. A young camera troop was buttoning up the last camera bay on the last aircraft. Sunrise was breaking over the eastern horizon as he reached up to lock the camera door, and the morning light revealed a fresh staff-sergeant chevron on his sleeve.

The new stripe wasn't all that important to him. This day, here at Takhli, everything just boiled down to the mission. There was work to do to keep the birds in the air and the weapons readied for the targets.

*****

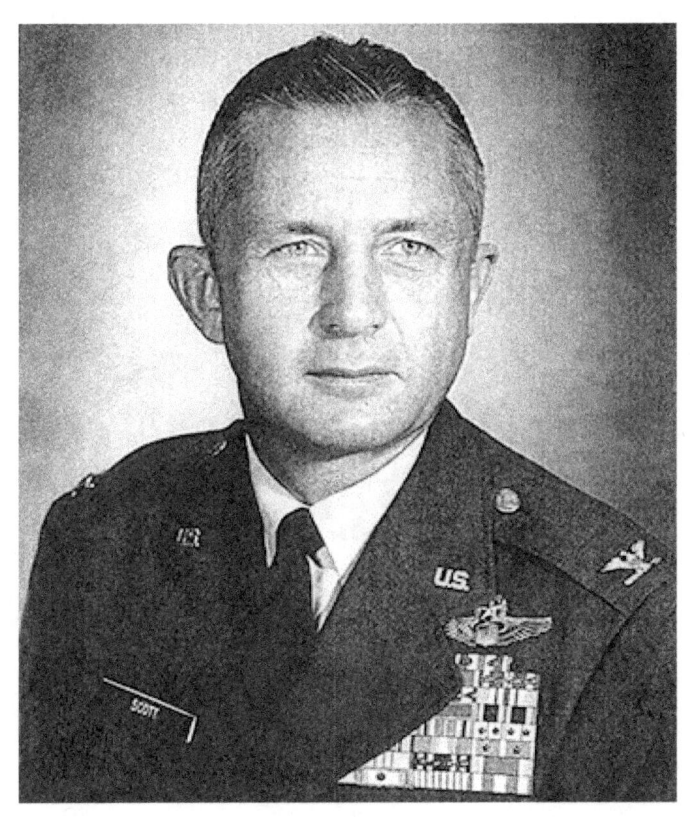

*Colonel Bob Scott*

# CHAPTER 5

## GEORGIA'S WAGON

Georgia had baked a pie. Riding within sight of Chupainas Camp I could see the tip-off: Dad's pickup was parked in front of our house. Sometimes I wondered how the fresh baked aroma of a pie cooling in the window was able to waft its way 14 or so miles to the Park Springs headquarters. In any case I knew Georgia and Dad had an understanding about that sort of thing, and if I ever thought he wasn't coming around often enough, Georgia's pie was an easy solution to the problem; and as it turned out this was a good pie day because we needed to finish up the branding plans. My baldfaced sorrel leaned up into a little faster trot toward home in the warm spring midafternoon sun, until we shuffled to a stop at the saddlehouse door in the old rock barn. Saddle and bridle, chaps and spurs, pulled off and put away, I dragged a canful of grain out of the feed barrel while my cowpony laid down and rolled on his back,

a stretching massaging ritual that signified the end of a long ride and beginning of a leisurely grazing afternoon. Bracing on his outstretched front legs, he stood up and shuddered the dirt off as I poured his reward out in the trough and opened the gate to the horse pasture. I rounded the corner of the barn, the prospect of a slice of her pie lightening my stride as I headed to the kitchen door.

They sat relaxed at the heavy antique table in enjoyable conversation, a frequent custom for the two of them. "Hey Dad". "Hi. ... Look what I found!" "Found? I think there was a plan hatched here. Did you leave any for me?" I washed up and sat at the table in front of a slice of lemon pie, his favorite, and a deep aromatic cup of black coffee – what a beautiful way to ruin an appetite. Georgia thinly hid her satisfaction with this perfect pastry, and she sat listening, with arms crossed on the table, as we ate and talked about what was left to do to prepare for the branding. The big problem was finding a wagon cook. We had been checking for several days through the list of former cooks. Last year's cook had passed away. "What about one of the Maestas brothers?" "Doesn't look like it. Christian is building fence and 'Sus can't leave the farm. Nazario has other work somewhere, too." "I tried Cecil Pino, but he has a job for the summer. That's about all the prospects I know. Anybody else out there?" "None I can think of; for sure none

that could handle a wagon." We sat in silence, over our empty plates, out of ideas.

"… I'll cook."

At first I didn't really believe I heard the remark. My coffee cup stopped halfway to my mouth. "Huh?" "I'll cook." It was coming from Georgia. "At the wagon?" I asked stupidly. "Yes," she said, annoyed, "at the wagon." Dad and I both looked at her with the same surprised concerned expression. "You don't want to cook for the wagon; that's the hardest job at the branding!" Visions came to mind of the cook starting well before the crew is up and quitting for the day long after they are in their bedrolls. It is, in the true sense, work; handling heavy dutch ovens, firewood, and the like; moving camp & equipment almost every day, setting and banking the fires, keeping the dirt out of the food and the cowboys out of the way, feeding them on time, or when they show up; and doing it all in the heat, the cold, the wind or the rain - 3 times every day after strenuous day until the spring work is done. Knowing all that, Georgia pressed the point. "What are you going to do? If I don't do it you don't have a cook – you'll have to do it yourselves." Dad and I looked at each other. She was right. We would have a crew of cowboys, but not a cook among them. The quality of life under those conditions didn't hold much promise; in fact, the prospects were downright bleak. We looked back toward Georgia. Sometimes she

could be maddeningly matter of fact - and right. "OK," I surrendered, "How do we do this?" "We'll get the wagon fitted out in a few days. You'll want to be there for that so you can take inventory and get it all like you want it," Dad said. "The boys'll help scrub everything out." "What if I pick you up tomorrow and we'll go to town for all the supplies?" "OK. I'm going to need a couple of extra things." That was easy to say yes to, whatever it might be. "A tent (oh, yeah – that makes sense.. ..hadn't thought of that), and I want a covered gas grill to use in addition to the fire, to use for some extra baking." (... baking my eye! She's been fighting for a new gas grill for months. Looks like extortion to me, but the price is right, whatever it is. Our new wagon cook can have anything she wants). "We'll need to get out the girls' bedrolls, too." Meredith had gone with me on the spring works since she was five, but this was going to be Avery's first adventure.

Well, we were off to a start, finally, having found the lynchpin of the spring works. On another front, it looked like the crew might not be as big as we'd like, but we would just take things a little slower and work a little longer every day. We had the permanent hands, including brother Cary, Delfinio Montano, and Francisco Padilla. Curtis Fort had promised to be there, and Paublin Romero had already showed up to help. All good hands, but the more I thought about it, the more I realized it

was going to be a long row to hoe, as shorthanded as we were.

We set the wagon up - fly, fire, and all - right there at the headquarters, making ready for the first day's work, mostly to be sure Georgia had everything she needed and nothing was overlooked before striking out. It was the afternoon before the first pasture to be gathered and we were standing around the camp in the shade of the big trees, pouring coffee all around. Curtis had arrived with a kid in tow, the 12-year-old son of friends who thought some ranch experience would be good for him. With Curtis around, the energy level was higher already. He dove in, moving quick to help the cook, peeling potatoes, getting the skillets hot and cutting the meat. Georgia had biscuits rising in one of the dutch ovens. "The spring works 'll work ok," I thought. "… not a big crew, but a good one."

A growing clattering noise beyond the little hill above the headquarters turned our heads.

Emerging from around the hill rolled a pickup and big rattling gooseneck trailer full of horses. As they pulled up in front of the house, all I could see through the windshield was two hats barely reaching above the dashboard, and 3 more hats just visible over the top of the cab in back among the pile of saddles and bedrolls. The engine shut off, and the driver stepped to the ground. I recognized Fletcher Mullins' two boys right away. Fletcher was the manager of the neighboring Conchas Ranch. "Hi Bobcat, how you doin?" Shaking my hand, the taciturn youngster said, "Doin' OK, sir. Dad said y'all maybe could use some help. He's pretty tied up with the spring works at the Conchas, but he wanted to send some hands so he split us off and sent us over." I turned my gaze to the crew that had piled out. The ragged little band of cowboys included Pistol Mullins and some of Ray Saiz' boys. I had first known Ray back when he was in the ninth grade and I in the fourth at the Chaperito School. He grew up working for the Conchas and was a good hand. But, what did we have here? Bobcat was the oldest, and I didn't think he was 15 yet. The rest were younger, probably somewhere north and south of age 13. They stood there, serious, 5 in all, hats pulled down square over their eyebrows and thumbs in their belts, sizing me up. "This is going to be an interesting wagon", I told myself silently. "OK boys, you can roll out under those trees near the wagon. Unload your horses up at the corrals. We won't turn

'em in with the remuda till tomorrow. There's feed and hay in the barn. When you've got everything squared up, I'll bet we can find something to eat." The boys started scrambling and I turned back toward the wagon. Curtis was already peeling more potatoes and Georgia was slicing more meat.

It was an odd sight that night, an encampment surrounded by bedrolls and soogans, low-lit by an ebbing cook fire, set among the buildings of the Park Springs headquarters.

The next morning breakfast was ready before light, and the men lined up for eggs, bacon, biscuits, potatoes and beans. The food was plentiful and good, coffee hot and rich, and we were getting off to an early start. I looked at the crew huddling over their plates and counted eleven kids: 5 from the Conchas; little Mike Gregory, son of friends from town; Kiko's 2 sons; the boy that came with Curtis; daughter Meredith, age 8; and Avery, age 6 – children all.

The sun peeked above the horizon behind the big rock barn as everyone headed up toward the horse corral. Dad stayed back to help Georgia. Meredith was holding my hand as we walked but, though just a child, she bore that independent serious intent that was already defining her character. The horse wrangler had gone ahead and was loping out for the remuda. The Conchas kids were already there, bridling their ponies. My jacket felt good as the deep orange sky, not yet shedding any warmth, escaped the horizon. As we carried our saddles from inside the barn into the rock corral, a rumbling beat announced the cavvy; more than 30 horses moving fast, topping the rise, funneling toward the gate. Feed had already been poured out in the long troughs along the rock wall of the corral. The jostling horses filled the corral and lined up to eat, occasionally challenging each other with ears laid back, controlling their space. The wrangler quickly dragged his saddle off the night horse and turned him loose with the others.

Soon the horses began to move away from the empty troughs and mill around as if they knew some would have a day's work ahead. They bunched up on the far side of the corral when the roper began to shake out a big loop and stride toward them. It was a rule at the Park Springs that the horses were always roped out, instead of allowing a confused free-for-all of men with bridles in hand and horses scrambling in teasing evasion around

the pen. The horses pushed to the corner, facing away from the roper, some ducking their heads to elude the loop. A name would be given and the rope would leave the hand, blossoming and rolling above the mass of horses, settling around the neck of the right mount. Accustomed to the routine, the selected horse would barely feel the tug of the lariat before wheeling and walking straight to the roper. The cowboy would bridle him, the next pony called out, and on down the line. "Give me the sorrel bronc." "I'm ridin' Ebony today." " ... Catch Seneca for me." " ... Wag." " ... Nick." "... the buckskin." "... I need Ole Janie." "... Big Enuff." ... It was not long before we were saddled up, hitting a long trot for the South Pasture, the first of a series of works that would take this youthful crew and its camp around the hundred square mile realm of the Park Springs over the next 9 or 10 days.

It usually takes a couple of days for the routine of a branding to come together. The flankers

have to get their timing figured out, details are overlooked, the ropers miss a lot. It tests the confidence of the crew and the patience of the boss. There is plenty of skill but no relaxed rhythm. The team isn't yet made. Then, in time, it all suddenly starts working when the men settle down and rely on each other as much as themselves. They learn, or remember, how to make a hand and pay attention, be in the right spot and do the right thing, stay out of the way and yet step in at the right moment. Then it all comes together, and the work will be done right and well. It becomes one of the things that distinguish good cowboys.

The Conchas kids were already a team, setting to their assigned tasks with seasoned and businesslike bearing; nothing childish or immature about their work. They were young, yet to be grown, but they were "hands". Away from the works with time to ruin, as I was going to witness over the following days, they would revert to childhood, running and teasing and playing the games of children, but when they walked into the corral or struck out horseback with orders from the boss, their demeanor was that of serious men on a serious mission. Their fathers, and other men of authority, had already begun to engrave a legacy on the centerline of these youngsters. Hagin Strauss, Curtis' young companion, would need some help, but he'd be ok if he didn't get in a fight or run over or something, and if he would pay attention to Curtis. It's a

good start, I thought, as we drifted the herd back to the pasture and paired them up.

Dinner was ready by the time we walked back down from the corrals. Georgia's chuckwagon was laid out the way it would be at every stop from there on out. A stretched 12X12 canvas "fly" shaded her kitchen, anchored on the wagon behind the chuckbox and held up by six poles made from wooden windmill sucker rods, guyed down tight with ropes and tent stakes. The fire was in a narrow pit about six feet long and deep enough to build up a fair amount of hot coals as the cedar firewood burnt down. It was dug parallel to the side of the wagon, around 5 or 6 feet from the edge of the fly. A narrow grate lay over the pit, under a long pot-rack with several s-hooks hanging a couple of feet above the fire. Dutch ovens hung on some of the s-hooks, containing meat and beans, chile, and more. The big coffee pot hung away from the hotter part of the fire having already boiled to flavor. A narrow serving table stood perpendicular to the rear of the wagon about 5 or 6 feet from the chuck box lid, when it was pulled down to make a work table, for the men to line up for plates, cups, knives & forks, and whatever food wasn't on the fire. Next to the wagon wheel she placed her new gas grill, in easy reach. On the other side a small twine string was tied loosely from one pole to the other - a resolute no trespassing signal intended for all but the

cook; slender and weak, but intimidating as the Wall of China.

As we ate Dad said "I think we ought to go ahead and get the wagon over to the fort. We can set up there and work both rivers, the Palmia, and maybe even the East Mesa before pulling up stakes." "Ok. I'll send some of the boys up horseback with the remuda. They'll need to fix the water gaps in the horse trap and check the corrals out. The rest can help Georgia get packed up and moved out." "We'll gather to the Salitre tomorrow. Somebody should take the branding wagon over and check those pens to make sure they don't have any holes, and then they can come on up to the fort." "…ok."

Tin plates started hitting the roundup pan and the men began to divide up the afternoon tasks. Saddling up, Kiko and his kid went with Cary, opening the gate on the remuda and hitting a fast stride north with them toward the Fort Corrals. Bini took a couple of the Conchas hands with him to take the branding wagon and check out the pens we would use to brand the Lower River pasture. After washing the pots & pans & dishes, the rest of the crew struck camp; dowsing the fire, pulling down the fly, and helping Georgia fold-up, pack-up and load all the plunder. The chuckwagon was put into march-order and hooked to the little army jeep, and all the bedrolls were hoisted into the bed of an old pickup. Meredith and Avery climbed into the

jeep as Georgia stood, hands on hips, in charge, assessing her expeditionary force with satisfaction, and a little anticipation. Dad saw us off, planning to drive up the camp early the next morning with fresh meat and other staples. Georgia and I hopped into the jeep and the cowboys mounted wherever the pickup would hold them. We were off.

The jeep's windshield was folded down on the hood, and a warm afternoon breeze met our faces as the little caravan made its way on the Chaperito road toward the fort corrals. Meredith and Avery sat behind us, holding the jeep's seat backs and bouncing slightly with the road's bumping rhythm, and dust rose from under the chuckwagon's old model-A style rubber tires. The pickup followed, piled high with beds, saddles, and equipment among relaxed cowboys enjoying the ride. Behind it lumbered the flat-bed truck, loaded with horse feed and hay, equipment, and extra propane bottles for the branding stove.

The obscure remains of Hatch's Ranch rests silently on a point slightly higher than its surroundings, overlooking the junction where the Aguilar creek ends its short trek from the rugged mesa country to the west, joining the Gallinas. This had been an army outpost of Fort Union in the 1850's and '60s, housing companies of Mounted Rifles whose task was to provide protection for the villages and early ranchers of the region below the great escarpment. This broken grama-grass and cedar country was the far western prowl of the dangerous Comanche; and the settlements, particularly those of the recent gringo arrivals, sometimes felt their sting. After their strikes they would evade the soldiers of Hatch's Ranch, vanishing eastward into the featureless expanse of the Llano Estacado.

By 1982 time had reduced the fort to little more than an orderly trace of melted adobe walls outlining long gone rectangular buildings and parade grounds. Only the rock stockade remained, with its narrow firing ports along the walls peering out in mute vigilance at the peaceful cedar dotted hills. Picket corrals extend from its north facing rampart, and once or twice a year the noises and action of cowboys and cattle works stand in for long departed echoes of mounted soldiers, trumpets, shouted orders and military bustle.

Lengthening shadows were already taking over the warm spring afternoon as our rattling entourage arrived and turned down to the Gallinas, where a rock bluff between fort and river provided an ideal protected campground. The cowboys hopped to the ground and disgorged the contents of the pickup. As we lined up the wagon, Georgia showed the boys where she wanted the fire and where the tent should be set up. From out of the wagon, stakes, poles, and canvas hit the ground, and dutch ovens, skillets, pot-rack and the rest were handed down – and that gas grill. We stretched the canvas fly on its wagon anchor and poles, tying the stake ropes hard and fast to the iron stakes driven in the ground. Georgia directed the placement of all the components of her kitchen while a couple of the boys struck out with an axe to collect firewood. The camp took shape quickly, and by the time the cavvy was turned loose in the little horse trap and the rest of the men were arriving from the lower river pasture, supper was cooking on the fire, coffee was hot, and the bedrolls were scattered around a well-ordered camp.

As the fire's glow died away and the crew slept, I lay awake in random thought, anticipating the next several days. The young crew was still somewhat untested. The pastures were going to be a little rougher and the cattle a little wilder. The days would be longer and the work more strenuous. Did I have a crew or not? Did Georgia have all she

needed? Would it rain? Then the regular night-visitor arrived, an accuser, the haunting economic reality of our business filling my mind. "Is this the last run?" Restless, I rolled over and peered beyond the flap of the tent into the moonless sky. "If we don't have this, then what is there?" I lay staring for a long time into a billion stars so bright against the blackness they seemed within reach of my mortal hands. They caused me to finally concede that worry is a futile and senseless thing. I was a minor player in the big picture. My hand couldn't reach any stars. The spectacular sky seemed to speak assurance that it didn't matter; that there was a Hand that could reach me. There was no point in trying to control the future. I didn't know when I closed my eyes, and slept.

Rousing from a dreamless sleep I heard the tentative call, out in the morning darkness, of a lone bird; a mockingbird I think, seeming to warn of a dusty rigorous day ahead. The eastern horizon was barely showing a hint of the day's light as I saw Georgia already up and about, stirring the fire and making preparations for breakfast. The coffee was ready, and I used my glove like a potholder to grip the hot handle and pour a cup. The crew stirred, sitting up from their canvas cocoons, buttoning shirts, pulling boots on, and coming to life. After Georgia's fare of eggs bacon and biscuits we headed up the slope to the fort.

In the receding grey we could see the horses moving toward the pens, the wrangler swinging his rope behind them in a lope. Sunrise began to wash the scene in red as they filed into the stockade where we had strung their pelleted breakfast out on the ground. In a few moments they all crowded at its west end, the roper shaking out his loop and stepping toward them. The day's mounts were called out, bridled, and led toward the line of saddles laid out on the ground in military order outside the rock wall. Little Meredith was sitting atop the wall, huddling against the crisp breeze, bridle in hand, waiting for her horse to be roped and led out.

Saddled up and mounted, the crew strung out in a long trot off the fort's little knoll, headed downstream for the lower river pasture. Cowboy protocol is subtle but stern, and in accordance nobody rides out ahead of the boss. I glanced over my shoulder at the moving mob of horsemen standing in their stirrups, tilting their hats against the cool morning breeze invading the river valley. "..sure a lot of kids back there," I thought. Weaving among the tamaracks, we found a crossing and splashed across the Gallinas, kicking into a lope on the other side. Meredith on her bay gelding, J Waggoner – "Ole Janie" - was keeping up alongside as we rode out on the flats and brushed past scattered stands of juniper. He was stout and good-looking, and a helluva cowhorse. He was also the attentive caretaker for this 8-year-old cowgirl. They

were compadres, those two. No price can be put on that.

I pulled my pony to a stop and opened the wire gate into the lower river pasture. Filing through, the men stepped off to adjust saddles and tighten cinches. Stepping back up we hit a fast trot, scattered the riders and starting the roundup that would end at a set of corrals in the middle of the pasture we called the Salitre.

The Salitre was the remains of buildings and corrals reputed to be the residence of the most famous, and infamous, of the Comancheros, Jose Piedad Tafoya, a 19th century entrepreneur and, by many accounts outlaw, who had traded contraband with the fierce Comanche for decades. Over a hundred thousand head of cattle, many carrying the brands of Goodnight, Hittson, and hundreds of other Texas cattlemen, are said to have been subject to Tafoya's enterprise. He had earned the trust of the

aboriginal proprietors of the Comancheria, and ultimately betrayed it under duress, forced to inform the army of their habits and whereabouts. Necessarily, after having made a mortal enemy of Comanche chief Quanah Parker, Tafoya retired from his trading ventures and settled here on the banks of a spring in the diminutive Salitre Creek to raise goats and live out his life. Now, like the fort, it was only a rock-strewn reminder of another time, fading from history into the grassy landscape, occasionally serving as corrals for the cattle works. By mid-morning the bawling herd of cows and calves were thrown together and pointed by the youthful crew toward Piedad's rancho.

The sun, with no shading clouds to block its authority, bore down hot. Jackets had long been abandoned and tied to the saddles as the temperatures rose to more common heights for the first week in June. Sweat was mixing with the rising corral dust as the work got done and the cattle were finally turned out. We loose-herded them while they mammied up, the calves all carrying on their left rib the fresh ruddy "flying U" trademark of the Park Springs. When all was settled I signaled with a slight wave and turned my cowpony away in a slow walk. The crew moved quietly around the herd and joined up for the ride back to camp, leaving behind grazing cows with calves insistently suckling their midday meals. We leaned into a long-

reaching trot, our minds turning to the meal awaiting us.

Hobbling our horses at the edge of Georgia's domain, we walked to the creek to wash up while the mixed aroma of cedar smoke, meat, beans and biscuits sharpened our appetites. Dad had arrived from the headquarters with essentials for the camp and was relaxing in a folding chair in a chat with the cook. Avery sat on a bedroll next to them, listening to childrens' tunes on a little tape player she had brought along. This camping adventure suited her fine. The line of men and kids filled their plates and found places on the ground around the wagon to enjoy the midday cuisine. Meredith and Avery carried their plates over and sat with their granddaddy; "Poppy", they called him.

In the heat of the day, calves will bush up while their mothers go to water, lay around, and then graze back. An afternoon gather may get the cow-count but yield too few calves, so at the Park Springs we usually branded in the morning and, later in the day, caught up on other works, like prowling back, checking fences, camp chores and the like. The Conchas kids helped wash dishes and straighten the camp, some of the crew rode out to check fences, and the rest pulled saddles off and turned the mounts loose. Some checked over the fort corrals and did a little minor repair to be ready for tomorrow. Two of the boys hopped in a pickup to go

retrieve the branding wagon left behind at the Salitre. Curtis and Cary led a couple of horses under the bluff to the shade of the cottonwood to reset their shoes. Dad, Georgia, and I sat near the chuckbox drinking coffee, talking some business issues and the next few days' work, and stealing an occasional biscuit. That evening the fare was light as the pink western colors faded into darkness and, in the glow of a couple of "white gas" coleman lanterns, the beds were rolled out for the night.

The next morning we splashed across the Gallinas and rode for the back side of the Upper River, where the river enters the Park Springs from the Conchas Ranch. Then we spread out and worked back through the pasture. The cows were busy early, scattered across the sloping breaks, grazing on new green in the mix of grasses and spring weeds. Seeing us, they nervously sought their calves and moved out ahead of the riders. We had a

lot of time so we rode easy letting the cattle drift out ahead and giving enough time to the riders down in the river bottom to stay ahead of us as they kicked cattle up onto the open plain.

The Upper River pasture is a broad L shape, laying around the southwestern point of the Mesa Montosa. Dad had taken some riders to gather the south part of the 'L', and as we came over the high point separating the two legs of the pasture I could see him about a half mile away in a slow trot headed across an open expanse of grass below the high bluffs of the mesa. Meredith saw him too. It was a good time to allow her some independence. "You ought'a go down there and see your Poppy. He might need a little help." I smiled as she took her charge with dutiful importance and reined Ole Janie in Dad's direction; but then, watching her long pigtail bouncing on her back as they loped away from me stung a little bit, and I stifled the impulse to call her back, to not let her keep following the inevitable uninvited path of growing up. In the distance I could see my father looking her direction and pulling up to wait. In a little while they were riding along together, no way for me to know what important things were being talked about. I reined away and rode down the slope to catch up with the gather.

We crossed the herd downstream from the camp, and one of the bulls in the lead stood stiff-necked, trying to challenge the cattle back across the running water, defying the will of the youthful cowboys. After a moment the big Hereford gave up and turned with the herd, insolently sweeping his wide reaching horns through the black mass of flies on his shoulders. The point man strung the leaders out toward the fence leading up the shallow slopes to the pens, passing well enough away to keep the rising dust from the camp where Georgia paused, ladle in hand, and watched her daughter and the big bay on the drag, nudging a couple of reluctant calves along behind the cacophonous procession. I saw that Cary's pickup was parked near the wagon and his wife Kathy was helping with the dinner. Avery and her little cousin Randi were sitting in the shade on a bedroll, playing and listening to that little tape player.

The cattle flowed though the gates into the picket corrals, where we sorted the cows and

bulls off from the calves and set up to start the works. A match was tossed into the propane branding stove, starting a roaring blue-red flame over the irons. Kiko cinched Big Enuff up and got ready to start dragging. The youthful flankers paired off, the cutter sharpened his knife, and I stuck the dehorners under my belt. Dad, with gloved hand, checked the irons and nodded to the roper. Kiko eased his mount into the crowd of calves and the work started. The crew was a team now, a body moving, acting, and reacting as one. As calves were dragged to the fire, the Conchas boys flanked them down and for a few seconds a swarm of action covered the ground. In less than a minute the calf was up and the flankers were on another. To the novice eye it was chaos, but in truth the work was a rhythm – a blending of men, cattle, horses, dust, and noise into a rough-hewn opera, ebbing and flowing on a stretched nylon rope bearing calves to the fire and cowboys expertly attending their work. And then, in a couple of hours, it was done. The roper signaled the end of his work by riding out of the mob of calves and loosening the rope from the saddlehorn. The fire was turned off, and suddenly the bawling of the cows along the fence in the next corral was the only noise left. Stringing the calves between us, we got the count and then turned them back with their mommas. The cowboys mounted up and rode out the gate ahead of the cows, holding them to a walk and pointing them to the little flat next to the river. They settled,

found their hungry calves quickly and started grazing the tender grasses on the banks, so we left them there and turned toward the camp a quarter mile away.

That morning out on the roundup we had witnessed something I had not seen before or since. It seemed every rattlesnake on the ranch was there in that pasture and out on the prowl. The riders killed at least ten, and I know I rode by that many or more in too big a hurry to stop and bother with them. The kids skinned several, and soon diamond patterns adorned saddles, hatbands, belts and anything else these creative little adventurers could get the skins to stick to, much to the chagrin of the cook and the two little cowgirls.

Georgia had a chili stew bubbling in the dutch oven and a stack of tortillas wrapped in a towel on the table. She was doing something with the gas grill, but was being secretive about its contents. I assumed she had a pot of beans and so was not as curious as the rest of the crew. The best way to get your hand broken at the camp is to lift lids without the cook's permission, so it remained a mystery for the time being. The crew lined up, taking plate, knife & fork, tortilla and a helping of the chili, and then scattering out among the bedrolls and gear to enjoy the midday meal and relax in the shade of the spreading cottonwood; veiling their curiosity about the gas grill. Georgia displayed little interest in it, adding to the frustration of the crew as they

covertly speculated whether there might be a treat under that lid. Then, finally, with all eyes secretly following her, she strode over and lifted the lid, revealing just a skillet, with some unidentified content.  She then turned the skillet over on a flat pan, lifted it, and there was a cake.  Imagine that – a cake at a chuckwagon! It turned out to be a pineapple upside down cake, the tastiest I think I had ever eaten. I think the men all fell in love with her, and the boys wanted to adopt her as their mom. I glanced over at my dad. He knew all along, having smuggled the fixins to the wagon.  They had an understanding about that sort of thing.

The cloudless afternoon was relaxed - a little fence fixing, some repair on equipment, tightening a loose shoe on one of the horses, helping with the camp chores.  Dad hung around the camp, visiting with Georgia and taking in a short nap. Avery and Curtis were at the riverbank, fishing, with real fishing poles.  "What other contraband do you suppose a feller would find around here", I mused. The boys had reverted back to being kids, running and taunting each other. Curtis' young travelling companion had started off in a battle with the Conchas kids, but now they were all pretty much indistinguishable, running and tossing a knot of cottonwood like a makeshift football and stirring up a lot of dust around the wagon. That's one of the cardinal rules, a capital crime – kicking up dust near the chuckwagon. The cook only

wants his (or her) own stuff in the food – not a bunch of dirt. Cowboys learn early in life to walk lightly there. Georgia chased them away with a mother's annoyance, so they took to the creek-side looking for other mischief.

Dad left for the headquarters, planning on bringing more supplies in the morning.

As dark approached I reached into a top drawer of the chuckbox and fumbled for the tin of Velvet tobacco and the little book of papers there, while Georgia kneaded a big ball of bread dough for tomorrow's rolls. I took the fixins with me to the corral to check on the nighthorse and pitch him a flake of hay. Walking back, I paused and sat on top of the low bluff to enjoy the last holdout of color in the western horizon and the descending curtain of darkness. I rolled up a pinch of tobacco in a delicate cigarette paper and, licking the edge to make it hold together, gazed down on the camp. Some of the boys were playing cards on the canvas of one of the beds, while a couple of the men sat on an old driftwood tree trunk, smoking and visiting quietly in Spanish. The river-bottom air was cooling quickly and felt refreshing after the hot day as I struck a wooden match and held it in cupped hands to my crude cigarette.

Georgia was working at the chuckbox in the light of a coleman lantern. She had spread a thin scattering of flour on the tin-covered table and was rolling out the dough with her rodillo.

Once it was rolled out, she sprinkled a dusting of flour on the dough and spread it evenly. Using the rim of a tin drinking cup, she cut a couple dozen of the doughy wafers and laid them in a lard-greased dutch oven. Then she kneaded the remaining dough and followed the same routine, filling the bottom of a second dutch oven and then setting both, with covers on, to the side of the pit, ready for morning. I watched her wipe and close the chuckbox lid and put everything in its spot, cleaning and arranging her dirt-floored, canvas-covered kitchen in impeccable order.

The evening light and noise of the camp had waned in concert with each other, and all were down asleep. The girls were in their bedrolls, outside on the ground, having abandoned the tent for open skied adventure. By the time had I picked my way down the slope to the doorway of the tent, Georgia was already in her bed and the lantern was out. I pulled my bed open and, laying my hat on the floor, quietly pulled my spurred boots off, undressed and crawled between the quilts. I lay still for a while, thinking about tomorrow. Then I heard Georgia across the tent, briefly stirring, and my thoughts turned to her.

After this many years, she was still an exciting, enticing, vexing raven-haired mystery. She combined more in her being than I in my literal simplicity could absorb. A rare beauty, fiercely protective mother, mistress of the house. At once a metropolitan sophisticate

and a country girl. A cordial hostess opening her home - a quiet recluse in its sanctuary. Self determined and aloof, yet essential to the world around her. Self reliant, sometimes defiant, cautious in her trust of people but completely surrendered to her Lord and Savior. At times inscrutable, maddeningly distant and cool, at others open and passionate. She was courageous, but didn't think so. As I drifted toward sleep I was thinking that here, far from modernity and society, she was a sustainer, a "mom", directing the campground manners of a migrating band of cowboy bedouins.

When I woke, Georgia was already busy at the fire, stirring it to life. Her quiet preparations were the only sounds in the mute, cool morning as a faint pale rim of light began to separate the broken eastern horizon from the black sky. Coffee was beginning to boil. A coleman lantern under the fly illuminated the small camp kitchen, casting faint shadows across the scattered canvas beds around the wagon. She had set the two bread ovens on

the ground near the grate on a little pile of hot coals from the fire and then shoveled a thin layer onto the lids. She laid out 4 pounds of bacon on a griddle, pouring its grease into two skillets, one for potatoes and one for scrambled eggs, and put the skillets onto the grate. Cracking a couple dozen eggs into her big steel bowl she stirred in a healthy portion of green chile. The sizzling bacon aroma quickened the crew as they rose to meet the new day.

The spring work had taken on its own life, a self-perpetuating rhythm moving across the broken landscape. Now, few orders or directions needed given. The cowboys, young and not so young, displayed that serious certainty and humor unique to the profession, the identity accorded the American cowboy – skill, dedication, independence, unassuming loyalty, confidence in the work, self directed life. It was a roving process: ahead, plenty of riding to do, cattle to be found, work to be done. Behind, trademarks stamped, cattle worked and sorted, all prepared for summer's long cyclic pace toward fall's shipping season.

We finished off the Palmia pasture that day, then the East Mesa on the morrow, the first of the rough pastures. Georgia brought burritos wrapped in big flour tortillas to us that day at the Chaperito corrals, promising a big meal that evening. It was a long day, and we arrived at camp near dark. Tomorrow would

not be a roundup, but rather we would use everybody to move equipment, horses, and Georgia's wagon all the way to the Aguilar Camp, in the heart of the Park Springs mesa country. After breakfast next morning, two men saddled up and started the remuda while the rest pulled up stakes. The boys folded the fly and tent, lifting them into the wagon with all the poles, ropes, grates, skillets, dutch ovens, the tent, and that gas grill. Beds and soogans were rolled up and loaded in the bed of the pickup. Dad left for the headquarters promising to bring more supplies to the new camp in the morning. Rolling out, Georgia at the wheel of the jeep, the caravan headed for the mesa.

The little jeep and wagon, with the pickup and truck following, rounded the bend at the Chaperito well and crept up the long grade of the "bajada" to the ranch's higher realm. Now we were in a country of heavy cedar cover with rugged sandstone & scrub-oak draws and canyons, a country whose wiley bovine residents would test the skill and savvy of this youthful crew. As we trekked past the Red Well, under guard of the high caprocks of the Mesas Quates above us, some of the cows with yesterday's fresh branded calves were already trailing in to water. The calves looked good, no worse for the wear, and to be watering out by this time of day meant good grazing, and the cows were getting their fill early. The warm sun would have them bushed up, with their calves hid out, pretty soon. The

air was dry and the sky a bright cloudless blue as we moved carefully over the rutted road.

Destination was the Aguilar Camp - sometimes called the North Camp. Jack Pate, the legendary cowboy who was running the Park Springs when my family moved here, nicknamed it the Honeymoon Camp - an old low rock house and picket corrals next to the creek, that had been a sometimes home for cowboys and their families, when those who liked or tolerated a far away life in a rugged setting, in its remoteness unforgiving of mistakes or injuries, could be found. But it was isolated there, and few families stayed for more than a year or two before needing access to schools or modern convenience, or just other people. I recall one pair of starry-eyed newlyweds that lasted 3 days. Leroy Satterwhite had lived there the longest. He said it was the best camp he ever had. A top-to-bottom cowboy from the old school, tough as a rawhide horn-knot, "Sat" had grown up in the Texas/New Mexico ranching history of the early 1900's, with the JA, the Matador, the D, the Turkey Track, and plenty others on his resume. His wife had died in the dust bowl days, and I think the lonesome peace of the Aguilar Camp somehow helped him stay closer to her memory. "Sally", as my generation called him, was around 86 when his swollen heart demanded he move to lower altitude. Reluctantly, almost in tears, he left the Aguilar and took a camp on a ranch back in Texas near Clarendon, and lived the rest of

his life there. After Sally, the Aguilar camp was used for occasional overnight stays by cowboys or hunters, and for a week or so during the fall works. The rest of the time it lay empty, patiently awaiting any next bit of activity in this out-of-the-way world. Nevertheless, it was an appealing place - far away, rustic, rugged, challenging, solitary; a place that would tug at a cowboy's alter senses for a little while, before the needs of family and responsibilities of the world would draw him back to reality.

I glanced over at Georgia as she managed the jeep through a deep arroyo crossing in the creek pasture. She was intent on her task, and I recognized a reflection of Meredith's dutiful focus when she had a job to do. The apple had not fallen far from the tree. When we rose out of the arroyo we could see the Aguilar Camp ahead, its tin roof glimmering like a mirage in the late morning sun. Georgia's little gypsy troupe would soon be

making camp, stretching the fly, digging the fire pit, standing up the tent, and all the other particulars. We would not use the house; it was better and easier to stay in the same routine. If a storm blew in, which from the look of the barren sky was about as likely as a steamship on the Gallinas, the boys could roll out under the protection of the porch. So, the wagon would be set a few yards from the rock house and our base of operations, and Georgia's kitchen would stay the same. We arrived and she stepped off the dimensions of her new HQ, directing how the wagon should point and where – and how – the boys needed to dig the pit. The kids were crawling over the wagon and pickup like squirrels in a tree, offloading equipment and beds, transforming the site into proper order.

Georgia was beginning to take on a nature characteristic of the brotherhood of professional wagon cooks: rulemaker, director, no-nonsense master of the sun-bleached, canvas shaded, dirt-floored realm; intolerant of broken rules or disrespect – a bit fearsome to these child cowboys – the only one on any roundup you for sure didn't want to make mad. Eager to please the cook, or at least not displease her, the youngsters jumped to their tasks with enthusiasm. Soon, the camp was established and the fire burning. Looking south I could see the wranglers, breaking from a brushy bend in the creek, bringing the remuda in.

Curtis and Kiko had taken the better horseback route, up into the Aguilar canyon, topping out at the Martinez trap and then on in to the "honeymoon". I looked up and saw the remuda coming at a lope, 40 saddlehorses flowing like a single, graceful, audacious, thundering creature. They ran the cavvy into the corrals, caught a night-horse, pulled their saddles off, and then sauntered up to the camp. These were two top hands in anybody's works; peers in the trade, but with origins in vastly different cultures. Kiko had grown up on the huge ranches of northern Chihuahua and had not spoken his first word of English before his 21$^{st}$ birthday. Poverty like none we could know on this side was familiar there, and about the only currency in that world was a cowboy's skill and a horseman's touch. Before coming to the United States, he had never owned a good nylon rope or more than one kind of bridle and bit, yet he could make a lariat speak and could bring a cowpony to do things the so-called horse whisperers only dreamed of. Curtis was every inch a cowboy, the product of west Texas and eastern New Mexico teachings, good enough to make a hand on the Pitchfork, the Vermejo Park, the Bell, and other of the big outfits. Whether working or playing (the two usually indistinguishable), mischief and humor were his companions. A gifted artist, he had the ability of expressing this life in bronze coveted by admirers of the cowboy way. Regardless of the surface disparity of these two cowboys, they shared a fraternity of

professionals that transcends culture and time.

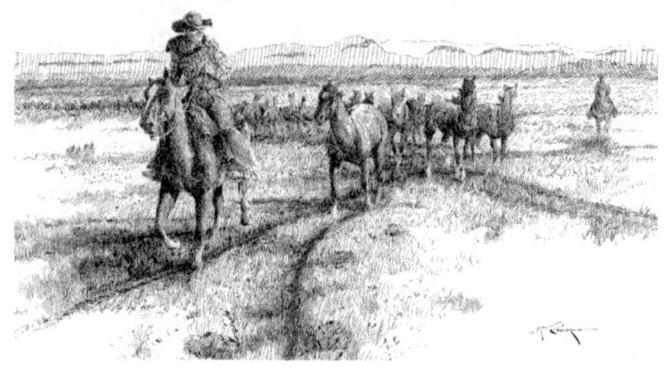

They settled among the rolled beds with coffee in hand, watching the saddlehorses wander out of the corral and past the camp to graze in the horse trap. With the fly stretched and tent up was little to do but relax and visit, and watch the ever more rambunctious boys run and play some respectful distance from Georgia's kitchen. The rest of the men got the corrals in shape for the next couple days' work. It was an easy day, a chance to take it easy and heal up a little bit.  We'd hit the Creek pasture in the morning.  Evening approached and the shadow of the old rock house stretched past the camp, the sun nesting itself in the horizon, far beyond the rocky bluff of the little trickling Aguilar Creek. After supper everybody rolled out their soogans and settled in for the night; everybody, that is, but the boys.

Dark had long overtaken the camp, but the quiet had not. The young boys laughed and giggled, wrestled, and roared at old silly jokes that lose their brilliance after boys relinquish their childhood, but not before. The noise and mischief persisted and I could hear Georgia shifting and tossing in her bed with decided irritation. We both finally found sleep sometime deep in the night, but not enough to appeal to this wagon cook's morning sweetness.

Working at the chuckbox with her back to me as I sipped from my metal coffee cup, she made the point, with curt economy of words, that the boys weren't stirring yet. I put the cup down and strode back to the tent, opened my war bag, and pulled out my six-shooter. Standing in the middle of the scattered bedrolls, whose bulges were stubbornly resisting the reality of a new day, I pointed the gun-barrel skyward and emptied the cylinder, inciting a panic of young bodies shooting from the openings of their beds, eyes wide but yet unseeing, mouths agape but wordless, minds trying to grasp the explosions. One of the boys attempted his escape in the wrong direction, colliding with the closed foot of his bedroll. "We're burnin' daylight, boys!" I declared, grinning, as they fumbled and searched in the dim morning light for their boots and clothes. The men chuckled as they filled their plates at the fire.

We struck out that morning in a long trot along the upper side of the Creek Pasture, kicking whatever cattle we were finding down the draws and canyons toward the Aguilar Creek. We hit the back side, and a drive was started with a little clutch of cows and calves that had been grazing near the Martinez Trap fenceline. Cowboys, scattered out ahead on both sides, gradually added to the size of the herd until it looked like we had the count, trailing toward the corrals at the Aguilar Camp. The point men strung the leaders up out of the creek crossing and to the open corral gate. The swing and flank riders kept the herd close together and the drag pushed up, keeping the cattle from taking a shot at escape. They flowed into the corral without a hitch and the riders immediately set to the task of stripping cows from calves and setting up the equipment.

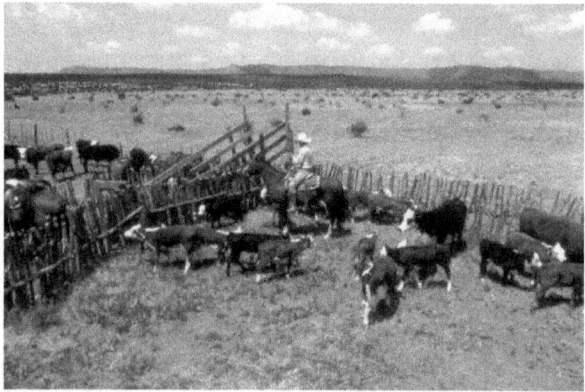

Inside the pens, I stepped to the ground for a few minutes and pulled my chaps off, hanging them on the corral fence. Then I cinched my

horse up, tied off my rope a little shorter and stepped up to start dragging. The flankers had paired up and all the other hands were ready – just waiting for the irons to warm up. From my horse I saw Georgia and Avery walking into the other side of the corral. Avery, with hat and boots and a determined look, had obviously come to make a hand. She did everything in life with the same dismissal of the concept of failure, and came to this branding the same way. "Poppy" joined up with her and they went over to check the branding irons. He glanced my way and signaled the start.

As I nudged this good sorrel horse toward the gang of calves in the corner of the cedar picket corral, I pondered the name Avery had given him years before. The Linkletter mantra, "Kids say the darnedest things" reminds us of who sometimes is really the family policymaker. In any case Avery's name for this good cowpony stuck and replaced his original moniker. I could only imagine my men talking about working for a boss who calls his horse "Rubber Ducky." Anyway, that's what she resolutely called him, so that was his name.

As RD and I snatched calves and dragged them to the fire, I could see in the action my father and Avery moving from stove to calf with the flying U iron. She would hold on to the shaft as Poppy helped guide and hold the hot script secure on the left rib. She was

always up for the plan, whatever it was, unafraid and unmindful of any notion she might not be big enough yet. With zestful courage, Avery would always meet life that way, part of the game. In many ways over the years, she was going to show the rest of us how to live, and how to call it.

Once the calves were finished up, we needed to take care of a bull that was limping pretty heavy on a front foot, probably a stick or something. Meredith's bay could handle a critter this size so I negotiated a short loan agreement with her and threw my kack up on Ole Janie, cinching it down tight enough for the job at hand. Mounting up, I shook out a big loop, stalking the big Hereford bull, oblivious as he pushed his way through the corralled cows, looking for whatever in the crowd may have need of his services. Kiko stepped up, rope in hand, on Big Enuff. The youthful cowboys were on the ground, squinting in the late morning sun, waiting for

the catch. I quietly pushed him out to the edge of the crowd and, standing in my stirrups, I sloshed a loop around one of his wide horns and under the other, around his jaw. In a sort of "half nelson" he'd be easier to handle than having simply caught him around the horns. Janie took a step forward and set his feet, anticipating a hard jerk. And it came. He braced as the bull hit the end, leaping and throwing his head against the constraint. Brute strength transferred its energy up my rope and jerked my saddle hard, but Janie calmly took the punishment with no fan-fare, anchored like a corner post. We pulled him away from the herd and, instead of taking a heel shot, Kiko rolled a huge loop over the bull's shoulder and picked up both front feet, folding the bull up in a one-ton thump on the ground and rolling him over on his side. Both ropes stretched tight as the boys swarmed the bull, running his tail between his hind legs and gripping it tight over his flank. A couple of them dug between the toes of the swollen hoof and found a little stick that had been driven into the soft flesh. Pulling it out, they packed the hole with sulfa powder. I pitched some slack to them and they pulled my rope off his head. Everybody stepped away as Kiko nudged Big Enuff forward and let the bull get up and walk away, already stepping more confidently on the sore foot.

The works had gone smooth, and soon the cattle were paired up and turned loose,

drifting toward the heavy brush. We rode back to the corrals, unsaddled and fed the horses. Mom and sister Jane Ellen were at the camp. Home for a couple of days from her nursing career in Albuquerque, Janie had a couple of days off and came to spend a little time at the wagon. Georgia had a big meal ready as we walked up from the corrals. The day was getting pretty warm, and the boys were shaded up under the gnarled cedars near the wagon as we forked up our meat 'n taters. Curtis had art business somewhere so he was going to be rolling up pretty quick to head off the mesa and back to civilization. All that seemed a long way off as we ate and visited under the watch of the high caprock above Aguilar Camp.

After dinner Bini caught the wrangling horse and went after the remuda. The youngsters, oblivious to that clue, were starting to drift over to their soogans and sleep off part of the afternoon. "Boys, catch your horses. We've got some more country to cover." The boys were tired after last night's revelry and looked longingly over their shoulders at their shade-blessed bedrolls. But, they dutifully pulled theirs hats on and headed to the corral. I visited with Curtis and his young companion as they threw their warbags and beds into the pickup. After these few days at the works, I noticed that Hagin had already begun to show a slight hint in his manner, a sort of "cowpuncher" seasoning. We shook hands,

promised to meet up soon, and I headed for the horse corral.

Saddled up and mounted, we headed across the creek and along the rim of a shallow canyon through heavy stands of juniper on our way to the Mujeres pasture. The Mujeres is a rugged little canyon cutting the middle of a pasture bounded on the west by an 800 foot high escarpment and on the south by the drop-off into the Chupainas country. It's rough and hard to gather. Cattle get wild here, and a few had escaped us when we cleaned it out a while back. Our job was to find the cows and their calves and get them into the LaLiendre. By the book count there was maybe six head to find. I had tied a short branding iron on my saddle so we could go ahead and take care of the calves when we had them captured. They would be pretty hard to find again once we turned them loose.

We scattered out in pairs and, taking parts of the pasture dictated by the terrain. Each set of riders had one that knew the pasture, and we agreed to pick up what we could and drive them to the Troncon Negro pens. We would just meet-up there and handle whatever cattle we had. I took Bobcat and hit a quick gait through the thick brush along the edge of the canyon toward the Red Hill, a rocky round-topped landmark near the pasture's southwest corner. We rode out that area and picked up two pair and a dry cow. One of the calves was a big one, probably born as early

as December. They were wild, and we had to ride hard to keep them together and in the open. Bobcat knew what he was doing, driving the cows in a run to keep them from separating and ducking into the brush, while I pointed the leaders up to the clearing along the road. Two more riders came out of the thickets, and we had them trapped. They seemed to know they were outgunned and settled down once on the road to Troncon Negro. At the Mujeres Well the boys had two cows and calves held up.

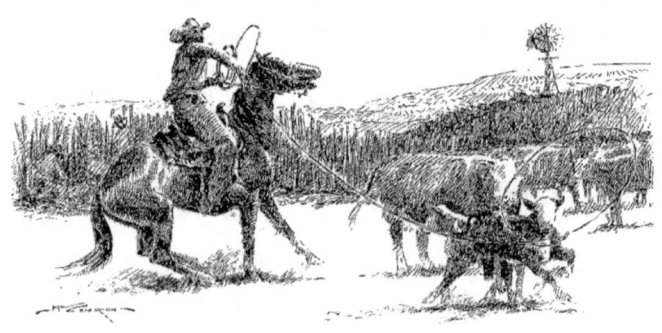

We'd done good, not leaving a calf behind. Once penned, we built a little fire to heat the iron and I stepped up on my buckskin and shook out a loop. The big calf was growing wilder and was hard to stalk for a heel loop. Bobcat yelled "just neck 'im!" The calf ran past me along the picket corral fence and I hoolianned him. The calf hit the end and

danced like a sport fish as I pulled him in a high trot toward the cowboys. Bobcat took hold of the rope and ran down it toward the calf, the rope sliding under his arm. When his left hand hit the loop at the calf's neck, Bobcat stepped into the bucking calf's side reaching over its back with his right and grabbing the flank. Hopping along with his bovine dancing partner he lifted the calf in the air and brought it to ground on its side with a thud. The other kids swarmed the fallen foe and had it flanked down and ready for the hot iron. Smoke rose, a syringe was produced, a knifeblade flashed, and the new steer was let up to run to the little bunch in the corner. The other calves got their mark and we mounted up to go back to camp, leaving the corral gate open for the cattle to drift into the little adjoining horse trap, where they would stay for a couple of days. We would be rounding up the LaLiendre the next day and there was no point in gathering these again.

We hit a long trot on the trail that bent around north of the honeymoon camp. The boys were strung out behind me; quiet, with tired determined looks on their faces as the end of the day was finally beginning to become a welcome reality. Shadows were long and, as we rode past the wagon toward the horse corral, I saw the cook getting supper ready. Horses unsaddled and fed, we walked up to the wagon. Georgia was waiting for us with a big fork in hand to lift meat into the plates, but the kids didn't even look up, trudging past her

to their bedrolls and collapsing, asleep almost before they were in the canvas. The rest of us ate well that night, looking forward to a peaceful passing of the dark, somehow assured that nights would be quiet for the rest of the spring works.

In the late night blackness the only noise was an occasional muted rumbling of a distant thunderstorm; a hopeful lullaby as I nodded off.

The next day, we worked the La Liendre pasture, named for a small abandoned village on the Gallinas River just north of the ranch boundary. The north part of the pasture is an open plain, bracketed between the buttes of the Mesas Quates and the eastern finger of the Apache Mesa. It is said that Charlie Goodnight held his cattle in this natural enclave while negotiating their sale to Fort Union. The other end of the pasture is a rugged collection of shallow canyons and draws, thickly covered by scrubby pinon and juniper protection. The Aguilar Creek separates these conflicting landscapes like a guard between the two.

The works went well and by evening all was quiet as we planned out the next day – a hard one on short rations, gathering the roughest pasture and moving everything off the mesa. After everyone had gone down for the night I sat for a while beside the cook, enjoying the warmth of the ebbing fire. "How do you do

it?" "Do what?" "Look at you. Life at the wagon is scrufty in the best of times. But you're fresh as the morning, all the time. You've been like that from the start, while us ole boys just get campier by the hour." She just smiled a familiar ornery knowing smile, leaving me in the dark about her secret. I must have looked either very menacing or very pathetic in my curious need to know, because she finally showed mercy and unlocked her secret of camp life. "Everybody was gone, so I took a bath." ..."But the shower doesn't work in the house." "I used the tub." "There isn't a tub – only a shower!" I was getting frustrated, and she was enjoying it. "No, silly. I used the roundup." The 'roundup' was a #9 washtub used to collect the camp dishes for washing. It would have been stupid for me to say 'but you don't fit in a washtub', so I just glowered. She playfully looked out the corner of her eye at me. "Avery stood guard while I stood in the tub and poured clean water over my head." "At the fort, too?" I asked, dumbly. "No, there's a good swimming hole at the bluff where the little creek comes in." "Avery's a good lookout," she chuckled mischievously. Making my way toward the tent in the darkness, I was captivated but not surprised by her independent, bold, problem solving ways. "I love this woman," I mumbled to myself, my imagination holding on to the picture of a classic sculpted marble goddess standing in a washtub.

I was half awakened in the night by a restless east wind whipping the canvas and singing past the stake ropes. The first wind of any account we had had on the works so far, it felt like a strange intruder, an ethereal raider protesting our rude presence. I lay awake a while, wondering how many, before us, had tread this ground, how many horses painted for war had watered at this creek, how many coup had been counted here; how many other campfires had fed and warmed "the people" at this place. Maybe this wind signaled the only tribute remaining of a domain that had been theirs so long ago. Then the regular night visitor arrived; a thief, with hopeless reminders of the reality of the life we lead, and my thoughts turned to questions. If we don't have this, then what is there? Will the wind be our only legacy? The feather-adorned ghost warriors drove the cowardly visitor into the blackness as they sped past and away. With no answer, I fell back into deep slumber

In the grey of the predawn morning we lit out for the Aguilar pasture. I left part of the crew behind to help Georgia pack up and then follow the wagon with the truck, hoodlum wagon, equipment and remuda to the deep tank corrals. The horses would need to stay corralled this time, as there was no trap there, so the boys would give them a good drink at the deep tank first. Then they would pen the horses, help Georgia get set up, catch fresh mounts, and gather the surrounding plateau, holding herd and waiting for us to work in from

the other side. Meanwhile I would take part of the crew with me to hit the rough side of the Aguilar, an interlacing convergence of rocky meandering canyons and finger shaped mesitas, edged with cactus and covered with thick evergreen cedars and pinons. This would be a tough morning so I left Meredith behind, too. The plan was to brand at the deep tank, eat dinner there, then off the hill. After a long steady stand-in-your-stirrups trot, we entered the Aguilar at the "three gates", where the Creek, Mujeres and Aguilar join. I took inventory of my men in the early morning light as the rugged conglomeration of sandstone, oakbrush, and cedars covering the interwoven chasms and ridges lay with smug challenging patience across the Mujeres canyon.

The Aguilar couldn't be gathered by scattering riders in a roundup fashion. That was just a good way to miss half the cows and spill half of the rest – and, in the doing, lose a few riders for the morning if they weren't familiar with the pasture. It had to be worked in small parcels, governed by the character of the landscape; an isolated piece of mesa here, a canyon there, a rugged corner, a brushy flat, multiple little areas to be swept and then held until we had a drive together; half-wild cows looking for an escape as we guided them out of the rough parts in small tightly held bunches, sometimes in wild brush-crashing races, to finally be loose-herded in an open space, held in wait for all

the other little scouting forays. They seemed to surrender a bit once we had them in the open. It all took good eyes, good ears, good horses, patience, savvy, and skill. It also took nerve and willingness for occasional fast dangerous rides over wild rocky brush-choked ground.

Kiko and I jumped a little clutch of cows and calves on the Martinez ridge, surprising them as they were trailing toward the Calavera spring. Breaking into a run, they tried to hit the brushy slope to disappear across the rough little canyon below the spring. Kiko opened up his mount to head them off, rocks clattering under shod hooves and oakbrush crackling as it gave way to the chase. I stayed close on their heels to keep them bunched up so they wouldn't break in several directions, a favorite trick of brushy cows. We hit the crossing at the spring in a run and got them pointed up the trail on the other side. We didn't let up on them, knowing they would scatter if we took the pressure off. They were beginning to tire but were still looking for an escape as we slowed the pace a bit, stubbornly pointing for the open flat at the deep tank.

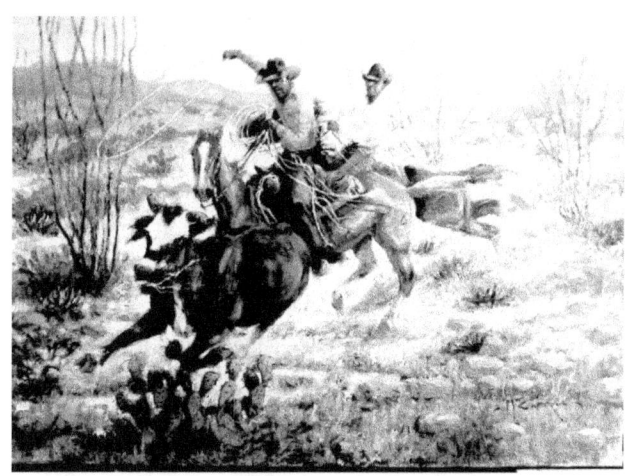

Other riders were working areas and bringing cattle out in similar fashion. Trotting with heads high and defiant, the cows would join the herd at the deep tank, and the cowboys, confident the herd-holders had them, would wheel back into the trees in search of more. Once captured, the cattle acted like there wasn't a wild bone in them, watering out and laying around, chewing their cud in content peace.

The branding went off without a hitch, but the day was hotter, it seemed, with the sun feeling hard and close. The horse herd stood off in one end of the larger pen, looking somewhat put off, having to be so near so much noise and dust, fighting off the horn flies, stickier than usual, that had accompanied the herd. Finished, we mounted up and drifted the herd back the few hundred yards to the tank and held everything till they were mammied up and quiet. Everything but the essentials had

stayed loaded up in the wagon, and on purpose the lunch was spartan, but tasty, as the crew sat cross-legged on the ground in a rough half circle with their plates of beans, meat and biscuits. Dad and I worked out the strategy for the next section of ranch to be worked.

"…All we got left is the West pasture and the Rincon. We can do them both at the Alamito."

"…OK. We'll have to take the wagon off the point. The road off to the Rincon had a boulder fall down onto it, and I don't think we can get the jeep and wagon past, or anything else but the remuda. One of these days after things settle down we're gonna have to take some dynamite and blast it off of there. We kinda need that road."

"…Yeah. The wranglers can take the cavvy that way – save 'em a few miles."

"…As steep as it is off the point, you'd better take the wheel. Georgia and the girls can ride with me. Given the choice of who to risk, I'd really miss her pies."

"Yeah, thanks." I quipped as the crew started packing up. Georgia, and Poppy with a kid on each hand, started over to his Suburban.

The road descends the mesa and the Aguilar pasture off 'the point' down into the West pasture. It's steep and precarious for about

the first half of the trip down. The second half is some better. The brakes weren't real good, so I pulled the jeep into "low granny" gear. That would be fine as long as it didn't jump out of gear, which the little jeep was known to do sometimes. If something went wrong, my plan was to hang on tight and crash it into the road bank – sure beats the alternative. Then, for reassurance, I reminded myself how seldom the jeep jumps out of gear. Then the only thing left to do was take a deep breath. After all the buildup, the ride down was as uneventful as I wanted it to be, and soon the convoy was on the road running along the length of the low flats under the mesa, headed westward. Two wranglers were coming down around the other side of that mesa, having taken the road that descends into the Rincon pasture.

The wranglers were already at the picket corrals on the fenceline between the West pasture and Rincon, next to the Alamito creek. They had watered the horses out and penned them. As soon as the truck arrived they took some hay down and scattered it on the ground of the corral. As I watched as the horses spread out along the line of hay on the ground, I considered the old saying that if you don't have enough horses on a ranch, you always have good ones. Maybe we could use a few more, but this remuda was how I liked it. A full pen of horses, strong and healthy, but pulled down pretty hard; hair set, fat rode off, bellies flat and tight. It didn't take much latigo

to cinch 'em up now, and when you did, you were dang sure horseback.

The road coming in from the highway crosses the creek at the Alamito corrals, and that seemed to the boys like a piece of civilization after the last few days. Georgia chose a spot next to a shallow grassy draw a little distance below the corrals, and the well-practiced crew had it put together in a few minutes; fires built, fly stretched, and gas grill in its appointed place. Thunderheads had popped up over the high mountains, drifting overhead and shading our world for a while before breaking up and wisping away. The evening was cool enough to almost need a jacket.

It was a long way to the backside of the West Pasture, and we saddled up early, depending more on the eyesight of our mounts to find the trail than our own. Looking over my shoulder, Georgia's wagon in the distance with its lanterns lit looked inviting, yet solitary – like a tiny lone ship in a black ocean of predawn darkness. It was too far away to see, but I knew that Georgia was tidying up after breakfast, no doubt running her mind over details for dinner. Avery would sleep in, and well after sunup she would be sitting on a little stool with her bowl of "sugar something or other" cereal, another bit of contraband stowed away along with those fishing poles and that tape player.

Gritty, whiskered, and unconsciously tired, the crew was on a roll, and wagon life had become normalcy. We had crossed a threshold in the work where the crew could just keep going from now on. Rising in the dark, catching out the horses, rounding up, branding, moving camp, sleeping in the canvas, living at the wagon in a daily round appealed to the intrinsic human desire for unique routine and culture. But very soon the spring works would be finished for another year, and in truth we would all be glad to get back to regular life. ... Right now, we had a pasture to gather, a big one, so we kicked into a lope as soon as the dim light allowed.

Below the mesa, the country in our last two pastures was easier, less brushy, and suited to a regular roundup again – kind of a good way to wrap things up. The West Pasture had worked good yesterday, and now we were about to get the Rincon finished off. Sitting up on a high point I could see the roundup coming together. The wagon had been out quite a while, and it showed in the quality of this crew. It is one of the pleasurable things in that life to see a crew of good hands working in unison to get the cattle works done, horses loose reined, riders scattered, cattle moving out. From where I was, the only way to distinguish the kids from the men was to know their mounts. In the distance I could make out the shimmering metal roof of the barn at Chupainas Camp, and realized we would be sleeping in our own bed soon if things went smooth. Above the Apache Mesa I could see the white hint of the top of a thunderhead, maybe promising a little shade by the time we hit the corrals. Below my perch, Poppy and Meredith had a little drive of cows started. Looking across this broken landscape to the horizons the advice of a wise friend returned to my memory: "Sometimes we get to thinking we own these places, but we don't, really. They're just given to our care for a while, …and that's all right." I touched a spur to my pony and we picked our way down the rocky slope to join the gather.

It was nearing noon when I dragged the last calf to the flankers and, pulling the horn knot

loose from my saddle horn, signaled the men to turn the fire off and call it a day. We drifted out, held herd, and mammied up for the last time. The spring works were finished.

Georgia had laid out a special dinner; steaks, fried potatoes, biscuits, mountain oysters, apple cobbler. Afterward we relaxed for a while, until the cool clouds began to spit a little rain and we figured we'd better start pulling up stakes. The boys helped Georgia get everything cleaned up and packed. Two riders had already turned the horses out and headed east to beat the rain. In a few minutes the little caravan was on its way.

We rounded the curve at the Park Springs headquarters and, pulling the caravan to a stop, everybody threw in and helped get supplies offloaded and equipment put away. Looking up we saw the wranglers and horses coming over the hill and flowing into the rock corral, where it all started 9 days ago. The Conchas boys loaded their cowponies in their gooseneck trailer and pulled up in front of the house. Getting out of the pickup, they made their way over to where the wagon was and, with hats removed, each said thanks to the cook. "It was awful good food, maam. We sure appreciate it." They each shook her hand and then came over to shake hands with the rest of the men. "Thanks Bobcat. You boys made good hands. Hang on for a minute and we'll get the checks for you boys." "Oh no sir! The ranch pays us. We're just

neighborin'!" I could have insisted, but the dignity in these boys' bearing deserved respect. "OK, well, I sure appreciate your help. Let us know when we can return the favor." "Yessir." "Tell your dad hello, and thanks." "Yessir." We shook hands and the boys, serious and self-confident, hats pulled down over their brows, loaded up and the rattling pickup and trailer disappeared around the little hill.

It had been a good day, and a good branding. Dark was approaching and, after deciding we could finish cleaning the chuckwagon tomorrow, I loaded family, and the gas grill, in our pickup and started for Chupainas. It was raining lightly and the lulling rhythm of the windshield wipers was taking its toll on my wakefulness. Wispy strands of hair had escaped Meredith's braids and framed her tired face, and she was leaning limp against my side in secure dreams. Avery, clutching her hat brim in one hand, head resting in Georgia's lap, was gone to the world. Georgia's eyes were closed but I think she was more in thought than asleep.

The road's darkness retreated from the pickup, headlights glinting hypnotic reflections of scattered raindrops. In the quiet of the drive, lost in my own thoughts, I recounted the work we had accomplished. The ranch was prepared for the next seasonal cycle. There had been no setbacks. Nobody, and no animals, had been hurt. As always, the

work had been hard but enjoyable, a kind of life that is rare in this modern world. People of this culture find humor in adversity and joy in the dust, grit, hard ground, and long days. My thoughts turned to what we'd thought we had – or didn't have – getting ready this year, and I realized that we are fools to believe we can predict how our needs will be, or should be, met. We could not find a chuckwagon cook; a lady was provided. We didn't have enough men to get the branding done easily; children were provided. I was shown something that spring about sufficiency, and how little of that I really have control over. Though we didn't know if this would be our last spring works on the outfit, the uncertain future was not to dread. Whatever the encounter, it will be fresh and exciting, and a new adventure. Sufficiency doesn't have to be predictable.

Then, the unwelcome night visitor, a liar, came into my mind's view at the side of the road, as if wanting to join this little family on its journey. I passed him by, and we moved on.

Purchased from Florsheim Mercantile in Roy, NM, the little rubber-tired chuckwagon had been in the family since the '30s, in the Coon & Culbertson days. Over the years it had been the rolling home base for a lot of cowboys and crusty old cooks, many of its memories having faded like the paint of the dim lettering on its sideboards. But its identity now would

always include the spring of the children, and the spring that it was "Georgia's wagon".

Psalm 37:25

*Coon & Culbertson Ranch
Romero, Texas, 1930's*

*Park Springs Ranch
Las Vegas, New Mexico, 1982*

# CHAPTER 5

## THE OUTLAW'S REWARD

There aren't many symbols more emblematic of the rural life than chickens. Stories and pictures depict chickens in every setting and circumstance, posing with homesteaders in front of their "soddies", in homemade crates riding conestogas up the Oregon trail, gripped tight under the arms of Indians on the run after a raid, hurrying across a dusty railroad-town street, scrambling out of the way of the lead steers of an arriving trail drive. Providing reliable staple nutrition, they were efficient, compact and gave two kinds of protein; one was delivered about every day of a chicken's career, the other just once. Chickens were also good to keep the barnyard's bug and

worm population in balance, including such undesirables as scorpions and bad spiders.

So it was at Chupainas camp. My wife Georgia always loved chickens, and usually had a flock of hens that was rather special, like her quiet-natured Silver Laced Wyandottes, gentle and dignified, or her Buff Orpingtons that added a golden glint of brilliance next to the earth-toned walls of the rock barn and faded red boards of the corral fences. Sometimes she would have a special rooster, a unique feed store discovery or gift from a friend, like the majestic Blue Andalusian that Duke Sundt had given her, a big blue-grey benevolent king that enjoyed a special neighborly relationship with the lady up at the house; or the big fancy fighting cock that had lost a bout and, in his retirement, was gifted to Georgia, riding to his new home on a spare tire in the bed of Paublin Romero's little Toyota pickup. For a while there was a flock of Rhode Island Reds, and though their brown eggs were wonderful, they are a rude breed, unattractive with no refinement or manners. Georgia, a beautiful woman of peace and order, required those same qualities of her realm; so, the Buffs or the Wyandottes were her choice, adding quiet attractive dignity to the barn areas of Chupainas.

Anton Chico was not far from where we lived, not more than 15 or so miles, a community nested among alfalfa fields and scattered adobe & rock houses along the Pecos River. It was a village that time would have forgotten, had the paved roads not been constructed connecting it to the evolving world. Even so, and in spite of the sometimes debilitating influences of "progressive" society, life was slower and traditions more sacred here. These were people of the land, whose seasons in life matched the seasons of nature, and whose internal timepieces were more tuned to the cycles of the acequia's flow or the churchbells announcing the Mass, or the in-and-out migration of the children of the school. Our two daughters, when they were small, attended the Anton Chico school, so we found ourselves linked to some of the

same seasonal life of the valley. Every morning, either Georgia or I would load the girls up for the short trek to Anton Chico, and that afternoon be waiting at the roadside as children poured from the schoolyard in all directions.

Flocks of chickens in barnyards and backyards engaged in their daily bustle all over this little rock and adobe community, and there is little doubt that egg sales at the local store were probably non-existent. They were fowl of every motley description and breeding, including a scattering of warrior blood, evidence of the local popularity of avian pugilistic tradition. The pre-dawn silence was broken every morning by the proclamations of countless roosters announcing a new day as dawn's rays began to strike paths of light along that farm-lined stretch of the Pecos.

It was spring, and the kindergarten teacher at the Anton Chico school had located an old egg incubator, seeing opportunity for a class project; so, she asked each child to bring two eggs from home. In that world all eggs were fertile, so it was a safe bet that in a few weeks the kids would be able to see the miracle of life cracking forth in front of their eyes, a worthy and wonderful experience for the little 5 and 6 year olds.

Avery picked a couple of eggs from the morning's bounty, Mom packed them safely

in a little box with some straw for the trip to school, and off they went on their voyage of discovery. Three weeks later, the children watched tiny beaks making the way for escape from white and tan shells; downy yellow and mottled chicks busily filling the floor of the incubator. The plan was for the kindergartners to eventually bring two chicks back home, and obviously the odds of a chick returning to point of origin was just about nil; so Avery's new chicks had begun in some other backyard and would have their own look. When they grew their feathers out that summer, Avery had a colorful gentle-natured little hen, part bantam, she named Henny Penny. The other was a rooster. Not very big, this pure white male stood slender and proudly erect, with flat comb and iridescent feathers covering neck and back. It was pretty obvious that at least some of this guy's ancestors spent more time in the ring than in the barnyard. One might have thought Spartacus or Rocky would have been a good moniker, but Avery liked "Ed", so Ed it was.

Sometimes, saddling up at the barn door, I would notice this undersized bully challenging whatever might be moving across his claim, appearing frustrated at the lack of respect paid. The trouble was he wasn't very big, so animals and people alike saw him as more of an amusement or nuisance than a threat. Ed didn't relent, refusing the notion that he was anything less than a dangerous force of nature, preferring to identify with the gladiator

side of his family tree, rather than the egg-factory clan. Anyway, Ed grew some that summer, but not nearly in proportion to his attitude.

Summer had begun hinting at the seasonal cycle toward fall and, before we knew it, the Anton Chico school bell was ringing again, and our routine included getting the girls to and from the village every day. Part of that routine included their job every morning of doing the chores, feeding the chickens, gathering the eggs, and pouring a can of grain to a saddle horse whenever one was kept up. Then they would come back up to the house, eat breakfast and get ready for the trip to school. The days started early, and sometimes the girls, age 6 & 8, would head toward the barn still rubbing the sleep from their eyes. Depending on the plans for the

day, either Georgia or I would load them up for the short trek to Anton Chico.

I am sure my children will tell you that I wasn't always a sensitive listener to their problems, and in this case their complaints about Ed bothering them was not getting the protective response they may have deserved. "Ed is being mean," they would complain. "What's he doing?" "He tries to chase us!" "Just run 'im off." "No Dad! He doesn't want to leave us alone!" " Just carry a stick with you, or maybe a broom. He is just a little chicken. He can't hurt you, just run 'im off." Each morning the conversation would end with the girls frustrated and their father oblivious.

One morning, Georgia impatiently asked me to go get the girls at the corrals. "They're taking too much time, and we're going to be late for school." I sauntered around the corner of the barn, figuring they had gotten distracted by some discovery, or had lost sense of time playing. Looking up, I saw the two girls all the way up on the top board of the corral fence, crying in frustration, and Ed on the corral floor. He had them treed, and wasn't going to let them down. The little bully had finally achieved a victory of sorts. I chased him away and helped the girls down, but they didn't exactly heap praise upon me for the gallant rescue; instead, they admonished me; "See there!? See what we're talking about?? Ed is mean!"

I hustled the kids up to the house and Georgia fed them a hurried breakfast. "I have to go on to the headquarters later this morning, so I'll take them – see you probably early afternoon." Helping them get their things together, she replied "I'll take care of the chores and feed the horse. You all had better get on down the road." With that we loaded up in my pickup and lit a shuck for the village. The drive was quiet, pouting quiet, except for an occasional subdued, almost hostile, "See I told you so" from Meredith, with an echo from Avery. Needless to say they were not interested in acknowledging my heroic role in their liberation from the top of that fence. I did get a kiss, kind-of, from them as they hopped down from the pickup and headed through the school gate.

The work at the ranch headquarters wrapped up pretty quick, so after dinner I drove back to Chupainas Camp to catch up on a few things around there and then get the girls from school. "I'm back," I said as I came in the door of our little rock home. Georgia had a sort of determined, "mission accomplished" look on her face, as she sat at the antique dining table sorting pinto beans for supper. "What's up?" I queried. "Ed's dead." "What?" "Ed's dead," she repeated with finality. "I shot him." "What? That's Avery's chicken! What happened? What's she going to say?!" She cast a brief hard glance sideways, as if seeing through the rock walls toward the corral. "Ed's dead, and that's that." More astonished

and curious than anything else, I again asked what happened, and Georgia laid out the events of the morning.

She had walked down to the barn, taking with her a plastic pail to collect the eggs. Crossing the corral past the barn door, in front of the little rock chicken house, she heard and felt a thump on the bucket. Looking down at the ground, she saw the little white rooster, neck feathers standing up, wings spread near the ground, in a menacing challenge to the lady of the manor. Ed was driving Georgia from his domain. She dropped the bucket and left the corral, but Ed was mistaken if he was thinking a battle had been fought and won. Knowing

my wife, I could imagine her purposed march back up to the house, and I could picture the look on her face, that of a mother with blood in her eye.

Mothers of most any specie will sometimes have 'the look'. They say that most animals do not have expressions like humans do, because they don't have enough of the right muscles in their faces, but tell that to the mugger in a branding corral when he sees that high horned cross-bred cow in the bunch who has suddenly realized the calf being wrestled to the ground is her pride and joy. That flanker will tell you the whole story is on her face as she looks over the top of the herd, and here she comes! The same can be said for just about any nurturing mother whose baby is under threat, no different for the human specie, and no different for the mother of the house at Chupainas Camp.

As she entered the house and opened a drawer in the bedroom nightstand, remembrance rose in her mind of an event as a very small child, when an ornery rooster jumped and spurred her in the face, and then the recall of a grandmother, with 'the look', turning the rooster's neck like a Model-T crank. She also recalled the plate of fried chicken on the table for supper that evening.

Georgia stepped back out of the house with 'the look' on her face, and her Ruger Bearcat six-shooter in her hand. By the pace of her

stride back to the barn, she could have easily been pictured walking alongside the Earps toward the OK Corral; and the outlaw that awaited her, just like those in Tombstone, was seriously overestimating his chances of seeing another sunset. Rounding the corner of the barn and entering the corral, her eyes met Ed's.

There are a few deciding moments in life where the battle of will and intent leaves only one option for existence standing and one relegated to purgatory. This was one of those moments. White hackles raised and wings spread low to the ground, Ed readied his attack with arched neck and strutting body, while the only sound in the corral was the ratcheting click of the pistol's hammer under Georgia's thumb. Ed viewed the strange object in her hand as it swung its long, orificed extension in his direction. He was planning his leap onto this odd appendage when he saw a blinding flash of light – then he saw nothing, except for the evil welcoming face of old Beelzebub, beckoning with one hand and pointing downward with the other.

The faint odor of gunpowder hung in the air and a slim wispy breath of smoke left the gunbarrel as she coldly surveyed the villain on the ground, a crimson streak spreading through the lifeless pile of white feathers. With no remorse Georgia picked the vanquished outlaw up by one taloned foot and slung him into a stand of tall grass outside the

premises, to become an unexpected meal for some passing varmint – a fitting outcome for this criminal, in her opinion. Her cool defiant expression gave wordless confirmation that nobody, but nobody, was going to be a danger to her children and get away with it. She stuck the pistol securely in her belt, picked up the pail, and finished the chores. The saddlehorse, having dashed to the back side of his pen, timidly eased back up to the feed trough, looking worried that he might be next, but then his fears were relieved by sight of the gallon of oats poured out by this gun wielding heroine.

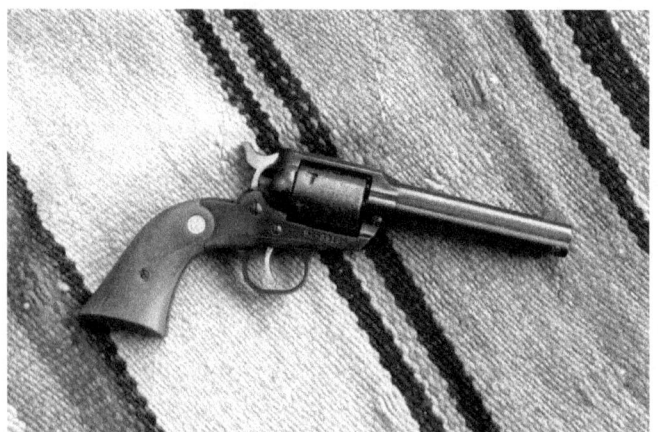

*"The Gun That Killed Ed"*

But now, I was going to have to break the news to Avery that the pet chicken she had nurtured since before it had hatched had fallen in a gunfight. It was time to pick the girls up from school so I left the scene of the battle and drove to Anton Chico. The drive back

was again very quiet, as I remained in deep thought about how to tell the girls. I finally decided it would not be proper to discuss such a tragedy while driving down the road, so I put it off until we got home. Sitting on the edge of a living room chair, I called them to me and, bracing for the sorrow of children losing a pet, said, "Girls, I'm afraid I have some bad news." They looked at me with faces of concern and dread. Without knowing how to sugar coat it I simply said, "Ed ...is dead."

The girls looked at me in surprise, then to each other and then to me again, as if they were trying to confirm they'd heard right. Then suddenly they broke out in a cheer, dancing with arms waving above their heads, chanting "Ed is dead! Ed is dead! Ed is dead!" I was taken aback, observing a scene mindful of the Wizard of Oz with munchkins dancing around and singing about a witch smashed under a flying house. Georgia stood in the doorway, leaning against the jam, arms folded, watching the celebration, wearing a subtle satisfied smile.

Law and order had returned. The gun was put away. Children walked the estate without fear while peace and order, reflective of the mistress herself, reigned once again. Georgia's chickens – and Henny Penny – waited patiently, without bullying interruption, each morning for the girls to trade a little grain tossed on the ground for a basketful of eggs.

'The look' had long faded from Georgia's countenance, as tranquility and dignity became the routine each day. She loved her children – and her chickens – and all was well at Chupainas Camp.

***

*"... and all was well at Chupainas Camp."*

# CHAPTER 7

## THE VOTE

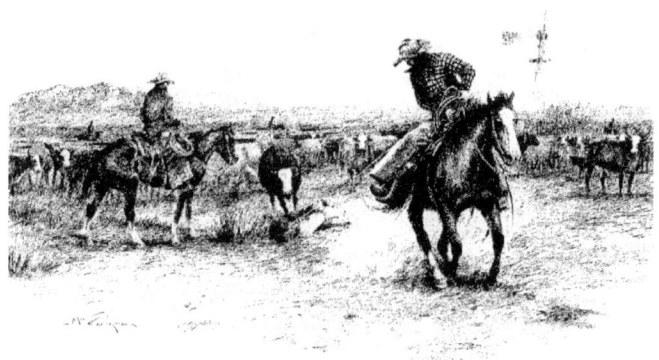

It all looked to be an easy morning. The spring works were in full swing and we were already "up on top" - in the ranch's mesa country. The chuckwagon was set up at the Martinez corrals, and we were gathering the Creek Pasture to those pens. I always liked the mesa; a little more rugged than the rest of the ranch, with heavier cedar cover and rocky canyons cutting past brushy slopes and flats. It was a bit more of a test for good hands and good horses, something that appeals to our youth and to our denial that youth will finally fade.

The Creek hadn't wintered a lot of cows so it would be a quick branding that day. It was the first Tuesday in June, 1972, primary election day in New Mexico. The light schedule worked in our favor, as my dad wanted to get the pasture branded up and

turned back out, turn the horses loose, button down the camp, and take the rest of the day off for the crew to go home and vote. Most of the boys lived in Dilia and Anton Chico, little farm villages on the Pecos River. We'd told the boys to take the next day off, too, knowing that once the polls closed and the bars reopened there would be celebration of the vote in the village, no matter which way the elections went. We were registered in a precinct up in Las Vegas, some distance away. When dad made the plan for this day, I was not surprised or particularly impressed that we would stop the spring works for a day or two just to go vote. It was, I knew, the important thing to do, but I was mostly looking forward to getting cleaned up and spending a little time in town with my wife; maybe a little shopping and, after several days at the wagon, getting to eat a nice meal at a nice table inside a nice café.

The pleasant morning was bright and clear, under a flawless blue sky that canopied mixed greens and tans of emerging spring grasses and sandstone cedar-breaks. Looking across the sloping pasture at the drive being thrown together, I could see my wife Georgia riding alongside my dad, coming up out of the little Aguilar Creek, following some cows and calves moving ahead of them in a hurried trot. My bride and I had only been on the ranch a while, having mustered out of the military a month previous, so these spring works were for me a return to the familiar life, and for my

wife a new discovery. Watching Georgia impressively sit her horse with straight slender comfortable ease, I pondered just how big a change in life she was experiencing, and how fully she was embracing it. Everything felt good and right that morning, right down to the horse between my knees.

Keno Red was his registered name; a handsome, modest sized, streak-faced, dark sorrel who had been my horse a long time, since well before I left for the service. Though he had been in other strings while I was away, it was as if we had never separated; a good pair. Four years away had not faded the familiarity that, after plenty of time and miles under the same saddle, settles into the bones of both horse and rider. A good cowpony but a little dangerous, I knew Keno well, with all his abilities and attitudes, plus a particular quirk that demanded healthy respect.

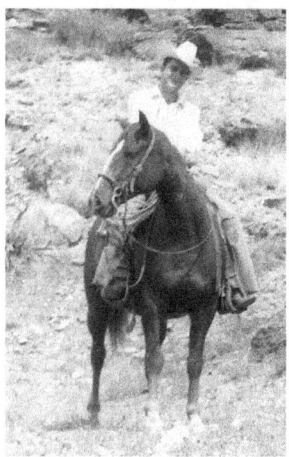

*Keno Red*

Keno did not like anything going on around the left side of his head. Whatever might be near him on that side, either in the air or on the ground, was a threat, and sometimes he would react. I remember when Duane Brockman, a little overconfident, found himself in that 3 year-old's strike zone and was knocked out cold by a lightening-fast front foot. He was always wary out his left eye, but I knew how to get along with him on his terms and didn't usually have much trouble that way. I could bridle him with little trouble, something most men couldn't do easily. Other than that, Keno was a top cowpony by anybody's measure. Sometimes to show off I would pull Keno's bridle off and work a herd, using just my feet to point him at selected animals and push them out of the bunch.

Keno and I joined the drive and pointed them through the gate of the picket corrals we called the Martinez. As soon as all were in, the crew jumped to action, separating most of the cows from the calves and setting up the branding equipment. "Dad, do you want to drag on my horse?" I asked. "OK," he responded. "I'll just use your saddle." He reset and cinched up, shortening his rope and tying off on the saddlehorn. Nobody in our part of the world dallied in those days, and roping "tied off" was a different more sophisticated art, requiring the roper to deftly handle the slack once an animal was caught.

The famous western poet, S. Omar Barker, in a poem about roping tied off, quipped "... either it's yours, or you're its."

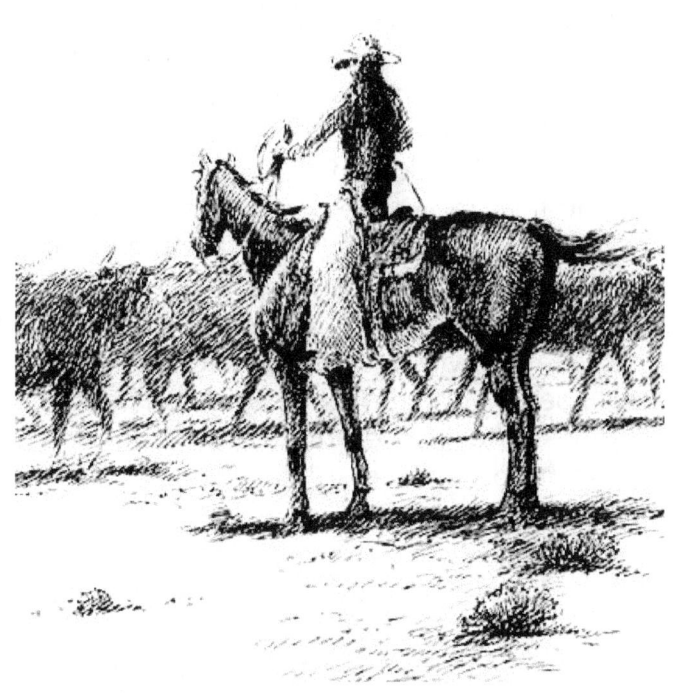

Irons hot, flankers ready, Dad and Keno eased into the bunch of bawling cattle, shaking out a loop and snagging the first calf. The crew fell into its rhythm working each flanked calf quickly, with always another coming in on the end of Dad's stretched rope. Georgia and I were standing next the branding stove as she filled a vaccine gun and I shifted the irons in

the fire. We watched the roper pick up a big "early" calf, probably born as early as December. He caught the calf deep, the loop closing around its flank and not loosening. Then, things started happening fast.

Bucking and running, the calf darted around behind the horse as Dad lifted the rope, ducking his head slightly to skillfully guide it over his hat, looking over his shoulder at his quarry. Dancing on the end of the rope, the calf ran up to the picket fence, ducked to the right, and then ran to the corral's corner. Dad started to pass the rope over Keno's head when I saw the horse, white-eyed, throw his face up high and away from the twined threat. I could see the wreck coming as the calf then ran full speed along the fence past and behind the right side of horse and rider through the crowded herd.

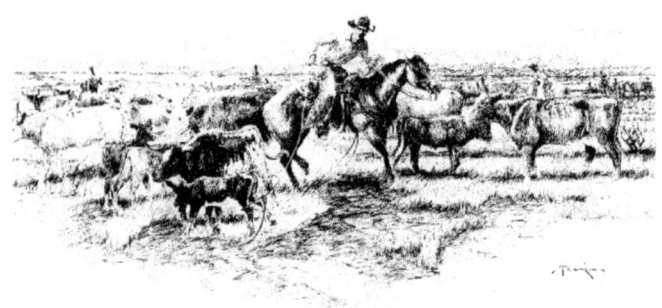

What happened next was probably over in less than three seconds, but the mind in a crisis can sometimes press the unraveling of

events down into extreme slow motion. The rope did not make it over Keno's head, instead catching in the shanks of his bits. I could see Dad reaching to get it untangled as Keno struggled fearfully to break the closing trap, the running calf heading for the end of the rope. Slack ran out fast, hitting hard against twisting bits and tender mouth. Helplessly, I watched horse, trapped, neck bent and head struggling - rider still in the saddle - flipping backward into the crowded corner of cows and calves. I heard a sickening thump, cattle leaping away in mass, and then like a riptide off the corral fence they were jumping and stumbling over the stretched rope and fallen horse, his legs thrashing skyward trying to regain something, anything, solid. Under Keno's inverted body, Dad could be seen through the boiling mob of cattle and dust. I ran toward the wreck as Keno tried to roll one way, then the other, panicked, pinning and mashing his rider into the ground. Finally rolling to his side, he jumped up, frightened, kicking his limp prostrate rider as he leapt away.

The next thing I remember is kneeling over Dad, along with Georgia and one of the cowboys. He was on his back and looked to be conscious but dazed. I said something stupid, I think, like "are you alright?" His eyes were half open and the trauma was obvious in his visage. "I think my back's broke," his voice hoarse with strain. Georgia comforted him as I dashed toward a pickup. My mind

racing, I knew I had to get help, and we were a very long way from it. I had to move, no time, no time...

Frantically cranking a trailer off the hitch of one of the trucks, I looked back over my shoulder to see Dad standing, Georgia holding him steady. Relief washed through me at the realization his back was not broken after all, but even at a distance he didn't look very good. He was pretty beat up - bent over a little bit, dusty and scuffed, but he said he was alright, just needed a little break. Georgia and I helped him sit comfortable on the ground in the shade of the picket fence before I walked across the corral to Keno Red standing in the corner, still shaken by the event. Picking up the bridle reins, I untracked him and stepped up gently, giving him time to settle down before shaking out a loop and restarting the branding. I suppose nowadays everything would stop in favor of finding medical care, no chances taken; but maybe people were tougher back then, or maybe just resigned to the fact that the remote isolation of ranch life must accept the fact of injuries, short of broken bones, and keep going. Anyway, he looked like he was resting so we finished up the branding and drifted the herd back out into the Creek Pasture to pair up.

The boys stayed back to put the campfire out and close up the chuckwagon while Georgia and I put Dad between us in his pickup to start the 15 mile trek back off the mesa to the ranch

headquarters. The road was rocky, with a lot of low rough obstacles and shallow washouts, making the journey slow as we tried to keep him as comfortable as we could. I felt like we were creeping but I would cringe, maybe even more than he, whenever I misjudged the road's ruts and bumps. As we moved carefully down the road, he broke the silence: "Don't tell Momma what happened." I wasn't surprised at the instruction, as that was his nature, but this was going to be mighty hard to hide. When I made that point, he simply said, "I'll do the talking."

Close to an hour had passed when we drove through the horse pasture gate and were in view of the headquarters. Rolling slowly around the little hill by the house we pulled up next to the driveway as Mom came out to greet us. Looking through the passenger window and seeing the obvious, her focused alarm was characteristic of a ranch woman who accepts the facts of a dangerous life, subconsciously braced for such eventualities, conditioned to respond instead of panic.

"What happened?" She asked intently, attention fixed on his condition. Georgia and I sat in silence, under his instructions. "I fell out of the chuckwagon." Georgia's and my eyes simultaneously rolled toward the passenger between us with the same incredulity. "That's his story!?" I thought to myself, knowing that Georgia was thinking the same. "You what?" Mom wasn't buying it.

185

"What in the world were you doing up in the chuckwagon?" " … gettin' a biscuit." I just slowly shook my head, and I saw my wife fighting off a smile at the new discovery about her father-in-law's mischievous sense of humor. Undeterred, Mom asked again; "Well, what really happened?" "Keno fell with him, " I interjected. "We'd better get to town. He may be clever but he's hurt bad enough to need a doc." Mobilizing, she answered, "Let's get him into the car," starting back to the house to grab her purse and close the front door.

In the back seat, Mom helped him get as comfortable as possible as the four of us started for the highway, another eleven miles of dirt road before reaching pavement. From there we were still almost 30 miles from town and medical help. Not having to worry about bumps in the road now, I was airing out that big Lincoln on the way to the hospital, figuring if a state policeman picked up on us maybe he would escort us on in. In the rear view mirror it was easy to see, even though he wasn't admitting it, he was in a lot of pain. "Does it hurt to breath?" "…kind of." "We'll be there pretty soon," I said, pushing the big car a little harder.

Pulling into town, I pointed the car up the main drag and caught the street leading to the hospital, when I heard a stir in the back seat and saw Dad trying to sit up and look around. "Where we going?" he queried. "To the

hospital. It's up this street." He knew that; I just assumed he was a little disoriented. "No, we have to vote, first," he retorted, like he thought I should know that. Georgia looked back at him as if maybe she didn't hear right. "No!" I argued. "We've got to get you to the hospital. Dad, you're hurt." Why did I have to remind him of that, I thought to myself. The expression on Mom's face pretty much told it all, predicting the victor in this argument. "If we go there first the polls will close," he said, trying to sit straighter in the back seat. "Lets vote first, then we'll find a doc," He said through a visible twinge of pain. "Dad, look at you, we need to get to the hospital!" Mom usually had no problem weighing-in when she knew what was right, but I could see by her resigned expression I was on my own. She already knew the futility of this one. Dad dug in, stubborn: "We vote." His immovable resolve would not be challenged. "We'll find a doc later." All arguments summarily dismissed, I conceded defeat and turned at the next corner, headed for the polls.

The voting machines for our precinct were set up at McFarland Hall, an old gymnasium on the high school campus that held a number of memories for me, having played ball, watched games, danced, attended concerts, sneaked out of assemblies, and generally misbehaved on its old hardwood floors during my high school career. Today, I was about to observe the singular event in my experience that dispatched those memories and embedded

McFarland Hall as an emblem of a bedrock principle.

Parking at the curb, I peered up the walkway and stairs at the gym's front doors.  What would normally have been a short walk with just a few steps up looked a little forbidding. Dad was stiff and getting very sore having been cramped up in the back seat for over an hour. We helped him get his sea legs under him while Mom went ahead to hold the door open.  She had plenty of time, because Georgia and I were his crutches, carefully helping him along. The stairs were slow, each one a task in itself. Once inside, we gingerly crossed the foyer through the big double doors onto the gym floor. The voting place was characteristically dignified and respectful. It seems when people vote they recognize that there is something important and sacred in their care.  The quiet but wide-eyed surprise of the voting officials reminded me we were a sight; dusty and tattered, having come straight off the cattle works.  I realized I hadn't even removed my spurs. We helped Dad over to the table to sign in, the lady at the roster a bit discomfited by this beat-up cowboy in front of her. They all knew him, but none had ever seen him like this; smudged with dirt, banged up, not the usual nice shirt and necktie he normally wore when going to town. Once signed in, Georgia and I helped him get to the voting booth. The old style machines had a handle up high that simultaneously closed the curtain and reset

the machine. He couldn't reach high enough so I pulled it closed for him. In a couple of minutes he was finished with his vote, so we helped him to a seat then voted ourselves. All done, in a grimace he said "Let's go find a doc."

The nurse opened the front door of the little community hospital to help us limp in. "Hi, W.O." The doctor looked over the top of his glasses and asked, "What in the world did you do now?" "Hi, Doc. Aw, a horse fell with me." He said, trying to front an all-OK attitude. I filled in; "The horse went over backwards, Doc. ...mashed him pretty good." "I can see that. Sit here, W.O. Let's check you out. You all can wait out in the lobby. Nurse, we should set up for an X-Ray."

Sometime later the doctor came out to report. "Looks like three cracked ribs, a bruised lung, and a bruised liver. He'll be fine, but he's going to be pretty sore for a while. I'd prefer to keep him here overnight just to make sure He's OK. You'll need to keep him wrapped up pretty good because of the ribs. Other than that, just keep him off any horses for a few weeks, especially the ones that fall down. Tell him to take it easy for a while."

Settled in to a hospital room, Dad was cleaned up and comfortable, having gotten a dose of some sort of pain reliever, while Mom, Georgia and I were scattered around in chairs, relaxed, glad that the scramble was over with.

"I should go back to the ranch tonight and bring you some clean clothes in the morning. That way the kids don't have to stay here. They'll probably discharge you in the morning so I'll be back early. Will you be OK?" "Sure. I think I'll just stay here." "Of course you will," she retorted, faking annoyance at the idea of him jumping up and doing the town. "W.O., did you remember your mother is coming from Dalhart to see us tomorrow?" We had all forgotten about that in the haste of the last several hours' events. "..Oh yeah, I forgot. ...Don't say anything about this." Georgia smiled, warning him, "She'll know, and you're going to have to come up with something better than the biscuit story." "I'll do the talking," he grinned back.

Well, he did have a story for her, but I don't recall what it was. I do remember she didn't believe him and started in on the 'everymother's lecture' about being too old for such dangerous work. Anyway, everybody was back on the ranch and into the routine, moving camp, branding, and attending to the spring works. He was supposed to stay at the house, but didn't. It was, however, with those cracked ribs, easy to keep him out of the saddle.

Many years have passed since that first Tuesday of June in 1972, but I look back often into its memory and still chuckle at Dad's hardheaded insistence about going to cast his vote. My quiet laughter is nevertheless laced

with a deep respect for what we, as well as the poll workers, the voters, the medical people, and others observed that day. Folks often use well worn phrases, respecting the vote as a right, a franchise, a privilege, and all the rest, but that day we witnessed the action itself give enlightened meaning to those terms, rendering them alive and declaring the simple act of a vote as the most basic arbiter of a free society. In 2004, my brother, W.O. III, part of a provincial reconstruction team in Afghanistan, witnessed their first national election in 5ooo years. He told of a young Afghan woman who wept inconsolably because she had lost her voter certificate and could not cast her ballot. My son-in-law, Matt Peterson, a Marine whose unit provided security in Iraq's first election in 2005, remarked "I will remember watching people vote for the first time in a democratic election for the rest of my life. Self determination is an amazing thing."

Early in 2011, the 3rd Battalion, 5th Marines at Sangin, Afghanistan, my son-in-law's outfit, had so far sustained the heaviest casualties of any unit in the history of that war, taking a key Taliban stronghold that had resisted defeat for years. The Secretary of Defense arrived for direct personal briefings from the battalion, accompanied by a Marine Lieutenant General who had lost his own son, right there, just a few months previous. At the completion of his tour and briefing the Secretary, with the General standing beside him, asked "Is there

anything I can do for you?" They could have asked for any number of creature comforts, but the Marines, dirty and tired, the strain of constant battle evident in their faces, were silent. After a long moment, a young Marine spoke up: "Don't let them forget what we've done here."

**Lima Company, 3/5
Helmand Province**

"...*what we've done here.*" The enemy was on the run. Markets were active again. Schools were reopened. The provincial governor was able to travel at will for the first time in years. The privilege of dipping a finger into a jar of purple ink and voting was brought to Sangin.

The restoration of those nations is a rocky trail, fraught with danger and risk, but if they will hold on to the vote, they will make it; if they don't, they won't. The courage and

defiance represented by an ink-stained finger there or the secure confidence in a signature on the voter list at the polling place here, mean the same thing: the destiny of a society, ours or theirs, belongs to those who have the passion and the gumption to vote, no matter the obstacles. It is a simple act, but with a price measured in inestimable blood and treasure paid out over history by those who know its value, often paid by those who have it for those who desire it. It is the same act – quiet, secret, sacred - whether cast in a remote village by an Afghan peasant, or in a school gymnasium by a busted up cowboy.

W.O. Culbertson, Jr. was a man of insight and principle. Had he lived long enough to see what my brother and son-in-law witnessed and experienced, I believe he would have enthusiastically wanted to hear every detail, and he would have said to them, "Well done. Remember what you've seen." He would have been amazed at the grasp for liberty being made by tribesmen in the middle-east and Asia. He would have understood with clarity their implications, and what their success or failure would mean for his grandchildren and great grandchildren. It would never have occurred to him that his own example would be the measure, the standard, by which I and my family follow the news of liberty on the other side of the planet. He saw things in simple profound terms, and simply would have known – and would have

told us all - "You have to vote." That's about all he would have said about it.

...and, in recollection I would add, even if a horse falls on you.

***

*"Don't let them forget..."*

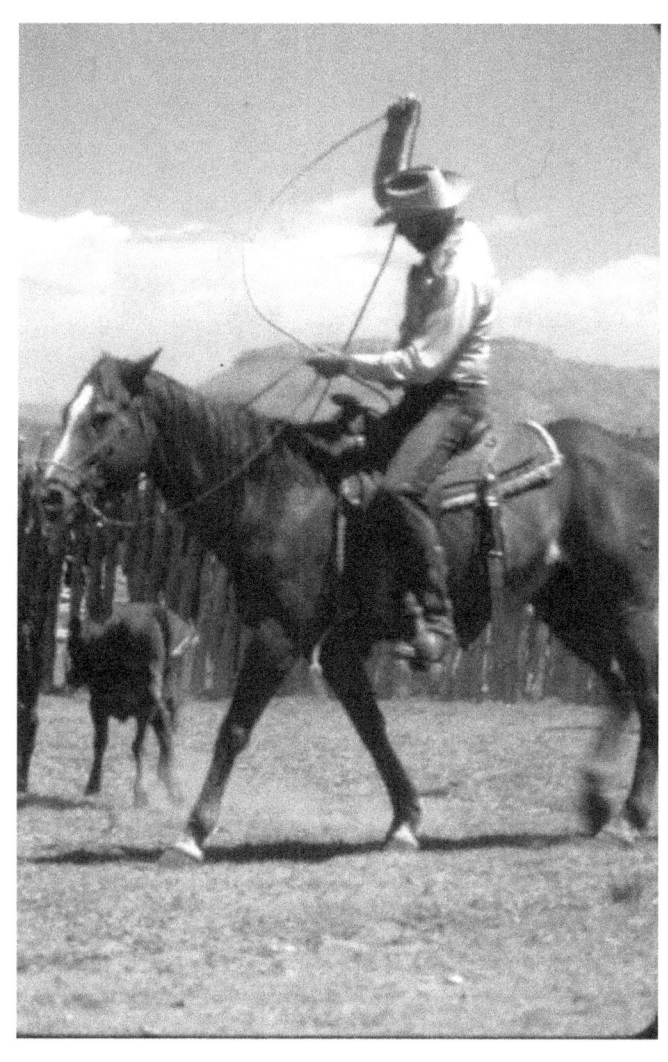

**W.O. Culbertson, 1982
10 years after "The Vote"**

# CHAPTER 8

## APISHIPA – A JOURNEY
## by Matt Peterson

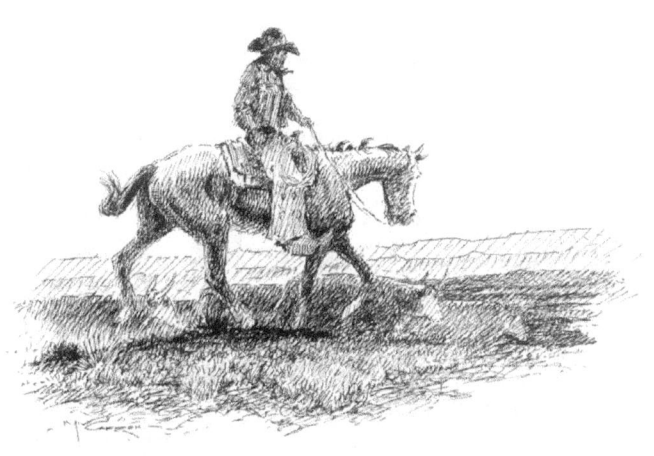

When I was a little boy I wanted to be only two things, a Marine and a cowboy. I joined the Marine Corps when I was 17 years old and have never regretted it. Across the world I have lived the adventures (though not quite like I had envisioned) that I dreamed of having as a boy. As I approach ten years of service, I have no regrets and I intend to wear the eagle, globe and anchor on my left breast pocket as long as the Corps and my wife allows. But life in the Corps can be rough and there are times when I crave an open range and a view of it with the mane of a horse right in the middle. President Ronald Reagan is famous in the Marine Corps for saying "Some men spend their entire lives wondering if they

have made a difference; the Marines don't have that problem." He also said, "There is nothing better for the inside of a man than the outside of a horse." The Great Communicator was right on both counts.

In the spring of 2007 I received a phone call from my father-in-law. He invited me to drive to the Apishipa Canyon Ranch in southern Colorado not far from Trinidad. Evidently, the Welch's were branding calves and needed help. The offer was to spend 8 hours driving to the ranch, sleep outside and work all day in exchange for getting away from the city, spending some time in a saddle, being around "sho-nuff" cowboys and eating Bonnie Welch's cooking three times a day. The trip was worth making for any one of those things so it appeared to me that I was getting the better of the deal. I had never branded calves before in my life so my first thought was that the Welch's must really need help if they were relying on a sod busting Infantry Marine like me, but I jumped at the invitation.

It didn't take long for me to pull my two pairs of wranglers out of the drawer and pack them along with four shirts that I hoped looked cowboy enough. I hand carried my palm hat on the plane and my boots were already at my in-law's house in Las Cruces, New Mexico so I was ready to ride in no time.

My wife Meredith and I along with our little girl Sophia spent a couple of days at Las Cruces catching up with her folks. Time with family is always time well spent, especially my wife's family, but I was itching for the saddle encouraged by my father-in-law Myles regaling me with stories of ranching and flanking calves (whatever that was) and I was excited when we finally got on the road and drove north.

Our first stop was the Hashknife Ranch in Watrous, New Mexico, which is without question the prettiest piece of country in the Southwestern United States. Before and after trips to Iraq I have escaped there and found peace on the back of a sorrel mare named Nifty trotting down the remnants of the Santa Fe Trail that are still apparent there.

The Hashknife is owned by a man most people call Dogie but is "grandpa" to my wife. Dogie and his wife Joyce Ann were out but they had left a horse trailer for us near a pen with a couple of mares and a gelding in it. An

hour or so after we arrived we were heading north again with two horses and a trailer in tow.

Traveling northward through Watrous, Wagon Mound, Springer and Raton offers views of country that I like to think my service to the nation protects in some small way. Crossing into Colorado from New Mexico we arrived in Trinidad and turned northeast. The drive was a period of transition for me. With the passing of each mile marker I emerged deeper into a world of grassy plains and very little traffic, which was a welcome change from my world in Orange County, California where the open fields and traffic exist in opposite proportions. I didn't give a thought to the war in Iraq, or roadside bombs, or ambushes. I didn't think about my next fitness report or where my career would take my family. We were welcomed by rain clouds looming on both sides of the highway, mountains in the distance and cattle grazing in fields adorned with signs indicating that the land was not for sale to the U.S. Army for further development of the Pinon Canyon maneuver area. I cleared my mind and eagerly allowed myself to be taken in.

I had never been there in my life yet it felt like I was nearing home. Two men, a father and son of sorts, in an American made truck hauling horses through rural Colorado on our way to do some real cowboying; I was happy.

We turned off the highway on to a dirt road scarred with the ruts of vehicles that had been stuck in the mud created by the rain that appeared to have fallen recently. After covering several miles and some bridges that made me wonder exactly how my wife would spend my life insurance policy, we noticed one of the two houses on the ranch. It was where Andy Welch, the ranch manager and son of John Welch, lived with his wife Rianna. As Myles pointed Andy's house out to me we noticed that some cattle had trampled a portion of a fence and had started crossing the road away from the pasture. We would have to be sure to tell Andy and maybe we'd have to ride out later and gather them back up. I was hopeful anyway.

We drove up to the headquarters shortly before the sun went down. After finding a place for the horses, we went in for dinner. I met the Welch's, Bonnie and John, who had restored the house into a western showcase of a perfect combination of art and hospitality. I expect the pleasant ambience of their home is a testament more to Bonnie than to John but the steaks we ate that night were John's creation and were as much a work of art as the western figurines and paintings that decorated the house.

After dinner I became acquainted with some of the other Cowboys. These men were from the Spade Ranches in Texas. John Welch is the General Manager of the Spade Ranches

and each of the Cowboys I met that first night were managers of the various ranches within the Spade Ranch company. After meeting them I did the best I could to take careful mental notes on everything. I observed the way they wore their hats and boots and spurs and wondered what was practical and what was preference. I have been to a few honky-tonks in my life and been around plenty of wannabes (I can spot my own kind) but these were not urban cowboys- all hat and no horse- these were the real deal.

Along with the Spade men there was also a boy named Gage Moorhouse from Benjamin, Texas. Myles had told me that in Texas, Cowboy is spelled M-O-O-R-H-O-U-S-E and he was right. Gage was 16 years old with none of the gawky self-consciousness that is usually typical of boys that age. He was accustomed to the Cowboy life and it suited him right down to the wild rag around his neck and the jingle-bobs on his spurs. Perhaps it is having a purpose in life and believing in yourself that makes the Cowboy persona so attractive to the rest of us and that was my impression of Gage. He knew who he was and what he was doing, which was a welcome change from most of the teenagers I know. He didn't even get flustered at the dead rattlesnake that the others had put near his bedroll.

Gage could shoot too. We drove around that night looking for a badger that never showed

his face, but we did manage to flush out several rabbits and Gage shot them with a M1 carbine as they tried vainly to escape the truck's headlights and Gage's steady shooting eye.

That first night we had had an unforgettable meal with good people in a beautiful house followed by driving around shooting rabbits; not exactly just another day in Orange County, California. The week was off to a good start.

We slept under the stars that night, one of the few parts of the trip that was not all new to me. The next morning I was treated to more of Bonnie's cooking and we finally caught our horses.

Nifty is a good mare and I like her for the most part but she gets a lot of time to herself out from under a saddle and away from cattle so she was predictably fresh from the start but we worked it out and we were soon riding deep into the Apishipa Canyon Ranch along with John and Andy Welch. I was living the dream.

At one point we crested an uphill road flanked on both sides by tall trees and rocky hills. At the top of the hill the horizon opened up into a panorama of a view whose beauty has no parallel. During my time in Iraq a number of Marines in my Company were killed and I know dozens of Marines from other

Companies whose lives ended abruptly in Iraq's sandy ground. Sometimes I am taken aback by the contrast between the stark ugliness and the indescribable beauty that exist simultaneously in the world we share and I find myself wishing desperately that those Marines were still alive so they could see how breathtaking the world can be. It is at those times that I feel most grateful to be alive and I truly try to appreciate the magnitude of what I am seeing and not take it for granted. I felt that way when I saw my wife after each of three tours of duty in Iraq; I felt that way when, home from my last tour, I met my daughter for the first time in person; and I felt that way as I reined in Nifty and let the others walk ahead. I stopped there for a few moments and thought of the names and faces of the men I knew that would never see such beauty on earth and I silently thanked God for His grace.

*Mortars Platoon, Weapons Co, First LAR*
*Anbar Province, Iraq*

We got the cattle collected from a pasture and drove them across the canyon of the Apishipa, into another pasture, near a corral where they would be branded the next day. The storm clouds were stacking above us as we loaded the trailer with our horses and we barely beat the rain back to the house. It rained, cold and hard, for the rest of the day and long into the night. The rain gave us the opportunity to spend some time in the barn assembling branding equipment and supplies for the next couple of days' use. Andy and Gage and I talked about a variety of things and I shared with them that I knew very little about the work that lay before us. Andy told me not to worry; he would have me flanking calves in no time. That sounded good to me but I still didn't know what "flanking" a calf meant.

Thankfully, the following morning the rain stopped and Andy didn't have to cancel the work he had planned. Several more Cowboys and their wives had arrived by that time including Andy's two brothers, Bob and Wes, as well as Tom Moorhouse, Gage's father. All together there were 16 hands and when we were mounted I was exhilarated to lope out to the pasture where the cattle we collected the day before were waiting to be gathered and branded.

We gathered and penned the cattle and, soon, most of the cows were separated from the calves. I was unclear about exactly what was going to happen next despite the best attempts of Myles and others to explain it to me. As a Marine I have been in several situations in which hard work compensated for a lack of technical know-how. Since I had nothing to offer to the branding effort but enthusiasm and brute force I worked as hard as I could. I wasn't sure how much of a hand I made but I was quickly covered in mud and sweat along with some spots of cow blood and other bovine matter. In what didn't seem like a very long time we branded 119 calves. I had taken a hoof in the chest (and did my best to pretend it didn't hurt) but I now knew what flanking was and, though others there may have disagreed, I flattered myself into thinking that I knew how to do it. The sounds, smells and sights of a branding are raw and

unappealing to some and, in a country in which fewer and fewer men will ever have a calloused hand in their lives, the work may not be attractive but I loved it and was anxious for more. I got it.

We branded more that afternoon and returned home to another incredible meal that Bonnie and the other wives and girlfriends had put together and that was punctuated by a bread pudding in a sauce that I would request be included on the menu for my last dinner on this earth. Tom told me to make sure I got some with plenty of the "slickery" on it and he was right.

The next day we finished the branding at Andy's place and I was much more confident in my flanking assignment though probably not much better at it. Afterwards we had a

final meal of brisket that we ate under some shade trees in Andy's yard as we sat in a large circle talking and laughing.  We had branded 340 calves in those two days and everyone, it seemed, welcomed the brief respite from the work proud of what we had accomplished together.  The aura was not unlike that that existed among my Marines when we had worked together to finish something difficult but meaningful. As I sat there taking it all in it occurred to me that being a Marine and being a Cowboy are not that different.  Hard work in support of the outfit is valued in both, courage is necessary and the danger is real.  Leaders take charge and are not questioned.  Both Cowboys and Marines make a real and significant contribution to the country and the lifestyle Americans have grown to love but seldom fully appreciate.  I am not a Cowboy, I don't even own a pair of spurs, but sitting there with those men and women I felt the kind of abiding content that a man feels when he is with his own people and in his own country.  In the weathered faces of the cowboys around me I saw years of rough but honest living like I have seen in Marines countless times.  I saw in the women there the beauty, strength, grace and tolerance seen in women that have grown accustomed to an uncertain and challenging life with a hardheaded man.  I have seen that type of woman before; I married one. These were my people and being there with them was what I needed.

After a few goodbyes I mounted up and started back to the headquarters to pack up for our trip back to New Mexico later that day. I noticed Andy running in my direction. He shook my hand and said that he was thankful to me for coming and that I made a good hand -- as if I were the one who had helped him.

No, Andy.    ... It's the other way around.

***

Matt Peterson enlisted in the United States Marine Corps straight out of high school. When his hitch was completed he enrolled at New Mexico State University. The attacks of 9-11 occurred his senior year, and Matt decided he should re-enter service. Upon graduation in 2002, he rejoined the Marines as a commissioned officer. He and Meredith Christine Culbertson married January 2nd 2003, three weeks before his departure for Kuwait in preparation for the invasion of Iraq. Matt is a veteran of three combat deployments in Iraq and one in Afghanistan. He completed his career as Operations Officer and Parade Commander at the prestigious "8th & I" Marine Barracks in Washington DC. Matt and Meredith have two children, Sophia and Harlan, and now reside in Liberty Hill, Texas.

***Andy, Me, Matt***

*ADIOS, AMIGO...*

*SEE YOU AT THE FALL WORKS!*

| Myles Culbertson<br>343 North Fairacres Road<br>Las Cruces, New Mexico 88005<br><br>myles@culbertson-partners.com<br><br>www.culbertson-partners.com/the-culbertson-letter | Mike Capron<br>P.O. Box 176<br>Sheffield, Texas 79787<br><br>mike@mwcapron.com<br><br>www.mwcapron.com |
|---|---|

www.ingramcontent.com/pod-product-compliance
Lightning Source LLC
Chambersburg PA
CBHW072135170526
45158CB00004BA/1379